american

CONTEMPORARY

FURNITURE

edited by **RAUL CABRA + DUNG NGO**
text by **MARISA BARTOLUCCI + CATHY LANG HO**
visual essay by **RICHARD BARNES**

Laurence King

8

EDITORS:
Raul Cabra and
Dung Ngo

TEXT BY :
Marisa Bartolucci and
Cathy Lang Ho

UNIVERSE EDITOR:
Richard Olsen

COPY EDITOR:
Iris Becker

DESIGN:
Raul Cabra,
Jeremy Stout and
Santiago Giraldo
for Cabra Diseño,
San Francisco

PRODUCTION:
Raoul Ollman
Tamara Marcarian

Published in 2000 by Laurence King
Publishing
an imprint of Calmann & King Ltd.
71 Great Russell Street
London WC1B 3BN
Tel: +44 020 7831 6351
Fax: +44 020 7831 8356
email: enquiries@calmann-king.co.uk
www.laurence-king.com

First published in the United States in
1999 by Universe Publishing
A Division of Rizzoli International
Publications, New York

© 2000 Universe Publishing

A catalogue record for this book is available
from the British Library

ISBN 1 85669 302 3

Printed in Italy

foreword | 10

preface | 12

introduction | 14

A M E R I C A N C O N T E M P O R A R Y F U R N I T U R E **Table of contents**

chapter I the EAST | **20**

the east | 22

new york | 24

chapter II the great in-BETWEEN | **94**

in between | 96

chapter III the WEST | **128**

the west | 130

bay area | 132

index/resources | 202

photo credits | 208

acknowledgments | 208

American design in the second half of the twentieth century has been markedly disparate in terms of quality and originality. Indeed, one can only point to two generations of international importance. The first group—led by Charles and Ray Eames, Eero Saarinen, and Florence Knoll—emerged after World War II and achieved the modernist goal of bringing "good design" to the masses. The second generation—postmodernists such as Robert Venturi and Michael Graves—achieved fame some two decades later by reviving a decorative tradition in design.

The 1990s has seen the emergence of a third generation of great promise which this pioneering book seeks to document. So how does one characterize these new designers? First of all, they do not constitute—at least not yet—a full-blown "renaissance," as was the case with Italy in the late 1950s and early 60s, but more of a "resurgence." Likewise, this generation has not yet coalesced into a national movement; the major leaders reside largely in San Francisco and New York City. Moreover, one cannot point to a ubiquitous "American Style." Indeed, many of this generation are global immigrants who have simply adopted America as their home and place of work.

There are nonetheless certain common characteristics that distinguish this third generation. They were in large part born after the mid-1960s. They believe in "design as art", though they are perhaps more realistic in seeing it not as a force that can revolutionize society but as one that can enrich it immeasurably. They desire to make inexpensive, functional objects that people can use and enjoy every day. Thus many of these designers would consider themselves born-again modernists, but there is a decidedly poetic, versus technological, bent to their work. Many have also embraced the concept of unity of design by accepting the challenge of working in multiple disciplines and media. Their formal vocabulary, however, can range from the geometric to the biomorphic, their sources of inspiration as diverse as Pierre Chareau to the Eameses. This new generation is also interested in the inherent qualities of the materials they employ and in the processes used in making their objects. Their approaches, however, can be as diverse as Ross Menuez, who seeks to evoke the expressive qualities of materials, to Nick Dine, who conversely wants to deny the innate qualities of his materials. Their materials generally tend to be inexpensive and "vernacular" through necessity: plywood, resin, and stock metal components. They use low technology for manufacturing, again out of necessity. Virtually none of their work is mass-produced. Rather, the designers rely on a retail system of small galleries, such as Totem in New York, or distribute through their own companies.

Lastly, it is important to note that these new American designers are no less talented than their European counterparts. What they are *lacking* is the support system afforded their contemporaries abroad: a society that considers design to be an important and integral

DOCZI LAMP
Ross Menuez
nylon

PETTERSSON
COAT RACK
Nick Dine
powder-coated
steel

part of its culture; a national manufacturing and retailing system that embraces emerging designers; and a lively, critical milieu consisting of schools, press, and even museums. Against such adversity, the achievement of this third generation is thus all the more remarkable.

It is, of course, still too early to ultimately judge this new generation. But they have clearly accepted the challenge to fundamentally change American design, as did the two earlier notable generations. And they have undertaken the formidable task—with the boundless energy, optimism, and irreverence of youth—to lead American design into a new century. A remarkable endeavor, indeed!

R. CRAIG MILLER
Curator of Architecture, Design, & Graphics
Denver Art Museum

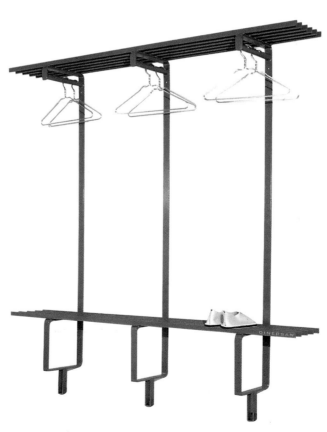

preface

As a graphic designer and an architect respectively, we have had a collective fascination, if not a long-standing love affair, with beautiful objects, particularly objects that derive their beauty, at least in part, from their utility. This love goes beyond the inherent characteristics of objects. It has to do with the wonderful, mysterious way they resonate with the personality of their owners and their surroundings. Good furniture often has this special aura, and it is from the perspective of people who buy, use, and enjoy contemporary furniture that we have assembled this book.

Several years ago, when we first met on another project, we started discussing how difficult it was to find well-designed, well-crafted, affordable furnishings. We were at an age when we felt the need to redefine our surroundings and reassess our belongings, most of which were acquired in our student days. Scouring flea markets and secondhand shops and, grudgingly, high-end vintage furniture stores in the Bay Area where we both lived, we developed an appreciation for the clean lines and socially conscious agenda of such American designers as the Eameses, Saarinen, and Nelson; the fine craftsmanship and modern forms of Danish designers like Hans Wegner and Finn Juhl; and the coupling of traditional materials with audacious forms achieved by such Italian designers as Gio Ponti and Carlo Mollino. We had also learned that this vintage high design comes with high price tags. We could afford, at most, only a few pieces. We looked for more affordable and practical items to complement our modernist treasures, and much to our amazement and dismay, could not find them.

With this realization we embarked on designing our own pieces and having them fabricated. As we looked for the right cabinetmakers, we discovered a number of local artisans who also designed their own pieces. Many of them had ended up in their present pursuits because they too hadn't been able to find furnishings that related to their lifestyles. This contact was the first step in discovering a whole world of designers who were attempting to correct the oversights of the mainstream market by fabricating new designs for themselves, their friends, and an enthusiastic emerging market. These designers wanted to create furnishings that expressed the design language of their own localities, one shared by residents and suffused with their collective history, cultural and ethnic influences, climate, and geography.

Thinking about regional influences on furniture design brought back memories of hammocks for both of us (they had been ubiquitous in the mountainous and seasonal Venezuela of Raul's childhood, and the tropical, ever-humid Vietnam of Dung's). We remembered how the hammock always differed according to the regional climate and landscape. In Venezuela, for example, along the coast, the *hamacas* were made of wide-open weaves and light materials. They would swing in the sea breezes of balmy afternoons, leaving unobstructed the views of blue all around. In

the high altitudes of the Andes, they were woven from thick, comforting wool yarns that were protective against the chill. Their colors blended with the muted green-grays of the area's sparse vegetation. In the endless desert of the northwest, there were the brightly hued *chinchorros* of the Guajiro Indians. The only point of reference in this barren landscape, these served as furniture and signage all at once. Variations similar to these, in different materials, colors, and uses, can be found throughout Southeast Asia and the world.

Like those hammocks of our childhoods, we have found rich contrasts in the furniture produced in different cities. The design seems to follow the mandate of locally available materials, access to production (or lack thereof), and the subtle references to the surroundings, be they natural or man-made. Furniture embodies the energy of the place where it is conceived, its romance or edginess, its humor or sobriety, its casualness or energetic rhythms. It made sense then that the scope of this project be that of a series rather than a single book—to best capture the influences, similarities, and nuances of different locales in their own right, whether they be in the Americas, Europe, or Asia.

This first volume in the series begins in our adopted country, the United States, and features many of the furniture designers and craftspeople we have come to know personally and whose works we have collected. Through our acquaintance with them and their work we have grown from admirers of the classics of modern furniture to collectors of contemporary furniture, confident in the quality of its design and its role as the classic furniture of tomorrow.

RAUL CABRA & DUNG NGO
San Francisco

Furniture embodies the energy of the place where it is conceived, its romance or edginess, its humor or sobriety, its casualness or energetic rhythms.

13

ROLLING SCREEN SHELF
Larissa Sand
steel frame, aluminum, translucent fiberglass

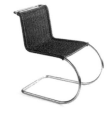

introduction

As we complete this book, it's late 1999, a pivotal moment to be considering contemporary American furniture. It's the close of the twentieth century, after all, the modern century. And it was the moderns who changed the way we look at furniture. An industrial revolution spurred their new design thinking, just as a communications revolution is informing this generation's. Chosen for its cutting-edge status, the furniture featured here reveals how enduring modernism's legacy is and how profoundly it has evolved. Most of all, these furnishings signal the resurgence of contemporary American furniture design as a cultural force.

If this has been the modern century, it has also been the American century. One can hardly speak about modernity without talking about America, as both movement and country staked their faith so fatefully in the promise of technological progress. We Americans have always embraced the new, ever since the first pilgrims set foot upon the wild shores of this "new world." Yet there has long been a disconnect when it came to our domestic lives, to our furnishings. With so much change around us, we wanted our domiciles to be

havens of the "traditional," even if it had little to do with our own traditions. Hence, the popularity of colonial furnishings among Americans who came to this country via Ellis Island, not Plymouth Rock. In Europe, the converse has been true. Imbued with tradition, surrounded everywhere by the past, Europeans compose the largest market for modern design.

Perhaps it was because of their strong tradition of craft that in the mid-nineteenth century the Europeans sought so earnestly to create a new art out of industry. The modern design movement was born out of the outrage of a small band of aesthetes over the way industrial processes were being employed in the production of furniture. They were appalled by the ersatz courtly furnishings being mass-manufactured for the middle classes. They detested the social pretention, as well as the bombastic use of ornament, which too often disguised shoddy workmanship. Furniture, they insisted, should address the way people truly live, it should be spare and expressive in form, its use of materials honest and inventive, its manufacture of the highest quality.

Theirs wasn't just a war of taste; it was a moral cause, led with a zeal befitting soldiers of the Salvation Army crusading to save souls. Modernism was a kind of secular religion. Its proponents would come to share an almost messianic belief in the more benefi-cent, equitable world that would arise once art and industry were wed in the name of functional form. At the time, however, most of their graceful, "machined" furnishings were in fact cobbled together by hand—practice having not yet caught up to theory.

Americans for the most part weren't afflicted by this moral striving. They were too busy devising true

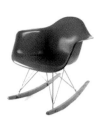

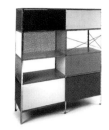

2 3

"machines for sitting," including the first mechanical chairs for barbers and dentists, all of which were typically fashioned after the most elaborate Victorian furnishings. In the making of this furniture, form and function never even shook hands. The aesthetics may have been questionable, but the approach was enduring. Out of this legacy came that quintessential American chair, the Lazy Boy.

It was only after the Second World War that America fully joined the modern furniture discourse. While many enormously talented Americans would contribute to what came to be called the Good Design movement, its undeniable leaders were Charles and Ray Eames, who as a team may well be the century's most influential designers. Certainly, they were its most authentic moderns. Employing new materials and techniques, this can-do pair developed furniture that lent itself brilliantly to mass production. These were pieces that truly corresponded to the way average Americans lived, instead of how the designers might have wanted them to, as was so often the case with their European predecessors. While many of these moderns had aspired toward an international style, the designs of the Eameses were unabashedly Californian, shaped by the fresh, open, energetic character of a burgeoning Los Angeles and the technology of its equally flourishing aeronautics industry.

With their casual, yet sophisticated, affordable furnishings, the Eameses inspired multitudes of Americans to embrace the contemporary in their homes and to live in a style appropriate to their times. They would even convince American industry—IBM, Westinghouse, Boeing, and Polaroid were among their clients—of the vital role design could play in their businesses. Wearing their influence lightly, the couple would blaze new

[1] MR10 CHAIR
Mies van der Rohe
1927

[2] RAR CHAIR
Charles & Ray Eames
1950

[3] EAMES STORAGE UNIT
Charles & Ray Eames
1949–50

[4] TEODORA CHAIR
Ettore Sottsass
1986–87

[5] GREENE STREET CHAIR
Gaetano Pesce
1984

[6] W.W. STOOL
Philippe Starck
1990

[7] MARSH-MALLOW SOFA
George Nelson
1956

paths in architecture, filmmaking, book and exhibition design, demonstrating just how wide-ranging and vital the role of designer could be.

But this enlightened moment was not to last. While in Europe contemporary design flowered as the continent rebuilt, becoming an essential facet of its postwar culture, back in the States it was already fading as a force. Of the many reasons for its decline, the most significant may have been the loss of strong contemporary design manufacturers. By the mid-Sixties, the country's two greatest, Herman Miller and Knoll, vigorous propagandists for the Good Design movement, had refocused their now multimillion-dollar businesses on the more lucrative, but insular, institutional and office markets.

Without the high-profile promotion, development dollars, and manufacturing muscle of these companies, contemporary American furniture languished. Americans once again succumbed to colonial taste, overcome by the marketing resolve of High Point, the country's traditional furniture industry (a quiet, change-averse behemoth with revenues vaster than those of Detroit). Likewise, American business lost sight of the crucial role inspired design could play in the strategic thinking behind the creation and marketing of products.

By the late 1970s, though, modern design was in a crisis almost everywhere. Designers had come to recognize that the world couldn't be addressed in a strictly rational way; it was too rich in "complexity and contradiction." In Italy, lapsed moderns like Alessandro Mendini and his group Studio Alchimia began designing quirky, decorative, referential furnishings and products that defied the movement's seriality, its machined aesthetic, anti-historical bias, and purist decorum.

4 5 6

One of the noteworthy members of this group was Ettore Sottsass, whose iconic industrial design had once defined sleek Italian modernism. With his international design collective, Memphis, he caused an uproar in the early 1980s with furniture that indulged in ornament, awkward forms, and bizarre combinations of acid and pastel hues. Cerebral in concept, polemical in intent, not to mention wildly expensive, it was utterly uncommercial. In addition to alienating many otherwise sophisticated Americans from contemporary design, the furnishings of Memphis and other postmodern designers helped drive a number of the country's few remaining design retail shops out of business. It had been these passionate proprietors who had helped educate many Americans about modern design.

The movement did, however, attract the attention of the media and, through it, the interest of a great many young artists, who were intrigued by these experiments in functional form. By the late 1980s, an art furniture movement had blossomed in the United States. Daringly unconventional in form, the work was highly personal, at times poetic, frequently whimsical. Much of it attempted to examine furniture's societal and archetypal meanings, its emotional connotations, and stylistic and conceptual conventions. It encompassed a diverse range of artists, from Wendell Castle who was pushing traditional woodworking to previously unimagined new limits, to Gaetano Pesce, the fabled Italian designer now based in New York, who was working with plastics and other contemporary materials and processes.

Also appearing on the scene in the 1980s was the maverick young French designer Philippe Starck. With his weird, futuristic designs of café and nightclub interiors (which were widely published), he whetted the appetite of Americans for exotically designed environments. In addition to a genius for self-promotion, Starck possessed a rare gift for creating flamboyant forms and a keen understanding of industrial process, a combination of talents which quickly made him the darling of a covey of European design manufacturers, and brought him industrial-design clients in fields ranging from cosmetics to yachts. For all his postmodern fancy, though, he held fast to the modernist conviction that good design should be available to everyone. If only the upwardly mobile design maven could afford his spiderlike aluminum juicer, just about anyone could practice dental hygiene with his flourish-handled toothbrush. With products like these available in the States, the ranks of the style-conscious expanded exponentially.

Starck's stylistic splendor became an emblem for the glitzy design of the 1980s and early 1990s. Wildly expressive furnishings began showing up in fashion layouts and music videos as fabulous props, exposing a growing audience to design's possibilities, if not its true ethos. In fact, more and more, design was being put to the service of fantasy. Disney, the ultimate manufacturer of dreams, started commissioning such star architects as Michael Graves, Robert A.M. Stern, and Frank Gehry to author "themed" office buildings and hotels, creating a whole new architectural genre: "architainment." Meanwhile, themed restaurants and clubs like the generic Planet Hollywood sprouted in cities across America; and in Las Vegas, casino operators built increasingly flamboyant hybrid casino-hotel-malls, replicating in their cartoony designs whole cities, even countries.

Starck himself, in collaboration with the hotelier Ian Schrager, would conjure surreal hotel interiors con-

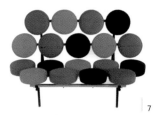

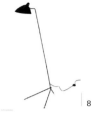

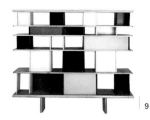

ceived as highly sophisticated stage sets for a new breed of clientele: the global nomad, who might have money or not so much, but who yearned to experience the trendiest spaces.

Whether high design or kitsch, all of this work was astonishingly different from anything done before. (The exception being the architecture of Morris Lapidus, who with his baroque Miami Beach modernism in many ways anticipated "entertainment architecture.") For better or worse, Americans were captivated by it. Throngs of them were now experiencing striking environments that challenged their sense of what an interior or building should be. To satisfy their new appetite for novelty, midmarket retailers such as Pottery Barn, Crate & Barrel, Workbench, even Ethan Allen, America's longtime pusher of colonial replicas, began offering fanciful "contemporary" furnishings.

However, rather than commissioning designs by some of the youthful art-furniture makers hawking this work, some of these retailers instead chose to "approximate" it, driving many budding entrepreneurs out of business—or just nearly. By contrast, in Europe, notably in Italy, these talents would have been cultivated and promoted by design manufacturers, the driving creative force behind the furniture industry there. This is partly why Europe has such a robust modern-furniture industry and America doesn't. While American retailers were finally recognizing that contemporary design could sell, they still didn't comprehend why designers were essential to the commercial equation. Design, as they understood it, was about styling, it had nothing to do with intellectual process. They weren't alone: most American businesses shared their ignorance.

Meanwhile, modernism was coming back in fashion. Beginning in the 1980s, retro-design shops, selling original furnishings from the first half of the century, started opening in New York, Los Angeles, and San Francisco. For the design-conscious who couldn't abide postmodern offerings, these stores offered a refreshing alternative. Here, many aspiring designers encountered firsthand the works of the Eameses and George Nelson, and had their eyes opened to the brilliance of Jean Prouvé, Charlotte Perriand, and Serge Mouille, French moderns whose work had previously been all but unknown in the States.

The appearance of retail design stores selling fairly affordable versions of modern classics also broadened interest. By the 1990s, midcentury classics began turning up as props in print and television advertisements, and as accessories in fashion boutiques. Once all but forgotten, midcentury modernism was suddenly and emphatically hip.

This rediscovery—or "remarketing"—of modernism has continued in uncanny commercial ways. A few years ago, Calvin Klein introduced a furniture collection modeled on the work of the revered minimalist sculptor Donald Judd. With his designer imprimatur, Klein gave these exquisitely austere pieces a commercial potential—albeit small—that would otherwise have been infinitesimal. Other fashion retailers The Gap, Banana Republic, Donna Karan, and Gucci have followed suit, purveying in their shops their own selections (and interpretations) of modern furnishings and accessories.

Or course, this isn't what the socially progressive early moderns dreamed contemporary design would be, but this is the reality of modernism in the age of

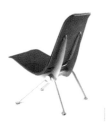
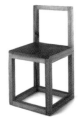

global consumerism. Design messages are now infinite and often incoherent. Nevertheless, amid this cacophony of styles, there is a stirring of something fresh. The way Americans think about their home environments is changing as is their experience of environment. Consider just how many now live much of their lives in the rationalist-conceived metarealms of the computer. Twenty-somethings largely grew up there. Technological change is the tradition this new generation holds dear. How then will its members furnish their homes over the next decade?

18 | Dematerialization has become the watchword of industrial design—think of the shrinking cell phone, the lighter, thinner laptop, the transparent iMac. With the iMac, the computer suddenly metamorphosed from work tool to fashion accessory. Consumers crave delectable high-tech products because they've grown so intimate with them. Now that life and work continuously interflow, these ever-present products have become emotional touchstones. If there is any logic to taste, it will soon run to furnishings responsive to high-tech lifestyles. Just consider how many more people are displaying their electronic equipment on media carts, instead of hiding them in faux French Provincial armoires as they did in the 1980s.

The furnishings in this book don't herald a new American design movement per se, but they do show the beginnings of a new mind-set, a new interpretation of modernism by Americans. Even though many of these designers came out of the art furniture and postmodern movements, you can see modernism's influence everywhere: in the eagerness of many to experiment with different technologies and materials, in the desire of all to create resolutely contemporary and functional forms. The forms themselves draw on a dizzying range of sources from rave music to extreme sports to minimalist sculpture.

Craig Miller, the design curator at the Denver Museum of Art, calls these American designers the "Third Generation," after the members of the Good Design movement of the 1950s, and the postmodernists of the 1980s. It's a roomy enough term to fit designers as diverse as the innovative hipster Karim Rashid, the determinedly understated Park Furniture, and the entrepreneurially savvy Blu Dot. But it doesn't express just what extraordinary hybrids of modern and postmodern thinking so many of these designers are. Or what an important, if surprising, influence locality has had on them. Different production shops, materials, people, and attitudes have all affected the way these designers create. In this dawning age of global culture, the fact that place still matters is an intriguing phenomenon. To highlight these differences, we have divided this book into three sections: East, West, and The Great In-Between.

While none of these designers are as yet household names, a few—Karim Rashid, in particular—appear on the brink of star status. Rashid's incipient celebrity is due in part to the energetic promotion of one of his manufacturers, the enlightened Canadian furnishings company Umbra. (One hopes American design manufacturers will take note of this and get hip to the powers of marketing, especially as it drives just about every other American industry.) But celebrity doesn't seem to be what motivates these young designers; instead, it's a yearning to create desirable, intelligent, honest, necessary, and reasonably affordable furnishings, and to prove once and for all that contemporary design in this country can sell like mad. You can't get more modern than that.

MARISA BARTOLUCCI
New York

CHAPTER

I

the EAST

the east

When people talk about American culture, the conversation inevitably turns to the topic of brands—Coca-Cola, MacDonald's, Nike, Microsoft. But these belong more to a meta-American or global culture than they do to this country's grass roots. America is big and diverse. While homogenizing pressures are real and ubiquitous, the realities of locality—geography, climate, politics, economics, ethnicity—persist, creating often vigorous regional cultures.

To speak about the "East" then is to speak of another deceptive cultural monolith. It's just so big. Yet there is a certain energy that runs through the Atlantic Coast states. They are mostly urban, industrial, prosperous, with histories stretching back to colonial times. Through their many port cities, they have for centuries been exposed to foreign products and ideas. They are home, too, to many of the country's most prestigious universities, colleges, art schools.

The cultural vortex of the East, indeed of America, has long been New York. Yet while a part of the East, it also is apart from it. A world capital, it is intellectually, culturally, and, perhaps most important, economically more connected to the goings-on in London, Paris, and Tokyo than to those in Boston or Baltimore. That global outlook is apparent in much of the contemporary furniture being created by New York designers. It's outside this country that so many of them look not just for inspiration, but manufacturing deals. Because New York stands on its own then as a cultural region, we've chosen to address the contemporary furniture being produced there in a chapter of its own.

Despite New York's cultural high voltage, the smaller cities of the East are gaining in cultural charge. After decades of decline as their heavy industries collapsed, they are resurging as high-tech, communications, and service industries move in, attracted by the higher quality of life they offer along with low rents. With ambitious, energetic, well-traveled executives making their homes in cities like Atlanta, Pittsburgh, Charlotte, Providence, a new level of sophistication is spreading throughout the East, and with it a taste for more adventurous environments.

It's a trend that has largely been ignored by the American domestic furniture industry, however, even though much of it is based in the East, in High Point, North Carolina. Vast and lumbering, with little competition, High Point resembles Detroit thirty years ago. Spoiled by its monopoly of the market, the industry has largely resisted all forms of change in its approach to design, in its methods of manufacture and marketing. There have been some stirrings of change, but updated interpretations of art deco are about as far as these manufacturers have dared venture.

But increasingly the industry is being challenged at both the low and high ends of the market. The most formidable interloper is the Swedish company Ikea, which, since it arrived a decade or so ago, has been offering Americans contemporary furnishings at enticingly affordable prices. Used to waiting for months to have furniture delivered, customers have happily adapted to carrying off their furnishings flat-packed and assembling themselves—an approach High Point never would have considered. More competition is on the way from Target, the hip discount retailer, as it expands into furniture. Meanwhile, young and affluent Americans are growing less and less interested in collecting the same traditional mahogany bedroom sets as their parents. They want clean lines rendered in wenge wood, the kind of furniture they see in *Metropolitan Home, Elle Decor,* and *Wallpaper,* and on *Elsa Klensch* and *House of Style.* Having been inundated with the media's progressive style messages, Americans are at last responding.

Even though the East has always been on the forefront of industrial developments, it has long been slow to innovate in the realm of furniture design. While its tradition of furniture making dates back to colonial times, it wasn't until the early nineteenth century that it produced the first truly American vernacular, with Shaker furniture. In its elegant simplicity, its seamless integration of function and form, Shaker furniture anticipated the very precepts of modernism. Progressive furniture making continues in the East, but now largely in the even more rarified realm of art furniture, with works ranging from Timothy Philbrick's graceful renderings of traditional forms to the muscular baroque ironworks of Albert Paley. Meanwhile, in Maine, Thomas Moser has made a small industry out of handcrafting

In the early nineteenth century the East produced the first truly American furniture vernacular—Shaker furniture.

sophisticated reinterpretations of traditional furnishings, drawing inspiration from the spare utility of the Shakers as well as the elegant joinery of classical Japanese woodworkers. His success has bred numerous imitators throughout New England.

Designers of furnishings on the vanguard of style, however, are rare in the East. The pull of New York, its kaleidoscopic stimulations, its multiplicities of creative networks, is too strong. Still, there are a few individuals blazing new trails and perhaps seeding new communities. Among the most interesting are two women, both working in textiles. There is Denyse Schmidt who, amid the neat clapboard homes of genteel Fairfield, Connecticut, a suburb of New York, designs quilts that in their animated, asymmetric geometries speak more of the architecture of Frank Gehry and of op art than of Pennsylvania Dutch. Hers is a complicated résumé. She was previously a designer of children's books, and before that a modern dancer/performance artist. The legacies of these past pursuits appear In her quilts in their playful command of color and kinetics.

Frustrated with working on books, five years ago Schmidt returned to her first love, sewing, creating quilt patterns out of the doodles that filled her sketchbooks. Through informal research she knew that there were few visually arresting products in the contemporary bedding market. She bet that her quilts, coupling a modernist aesthetic with handicraft, might prove an enticing addition. Today, she has seventy Amish women in rural Minnesota busy sewing for her. Her quilts sell in high-end boutiques and department stores across the country and in Japan. And she is producing a lesser-priced series, sewn in India, for Garnet

Hill, the rapidly growing, trendy linens catalogue based in Vermont—another sign of how the style market is expanding geographically.

Then there is Angela Adams, an interior designer by training, and former decorative painter, who has a thriving three-year-old business making retro-modern rugs and pillows in Portland, Maine. This picturesque city on Casco Bay is fast becoming the East Coast equivalent of San Francisco or Seattle, brimming as it is with both start-up high-tech and media businesses and artists. While no longer a booming industrial textile center, it still affords enough suppliers and factories to make it an excellent base for a rug designer. And Adams, a proud Maine native, hopes to find other in-state producers as she expands her line into other products.

Adams grew up in the splendid rustic isolation of North Haven, an island twelve miles off Maine's coast. Not a place seemingly conducive to developing a sophisticated abstract aesthetic, but in fact Adams was surrounded by modern influences, a tribute to how diffuse contemporary design had become in midcentury America. Her grandmother's house, like many on the island, was furnished with linoleums patterned with fanciful wavy grids and amoeba-like forms, along with Heywood-Wakefield furniture and colorful moderne draperies.

Adams likes the fact that these contemporary furnishings have endured for several generations. Being a practical Yankee, it's what she wants for her own work. Most contemporary designers and manufacturers play up the hipness of their objects. To buy them is to become part of a style elite. But while Adams's rugs seem destined to adorn the layouts of *Wallpaper*—they already decorate the floors of many Guess and Gap stores—she wants to design products her own family and friends will feel comfortable with. That the people of North Haven might want to live with Adams's funky patterns

should be an eye-opener to many American retailers and manufacturers. (At present, however, their prices put them beyond the reach of most boatbuilders and lobstermen.) But Adams isn't counting on the furniture establishment; she hopes to do an increasing amount of her retail business online.

The tradition of furniture design and production in the East seems on the brink of change. There are the talent, resources, and, most important, a growing, eager audience to nurture a whole new decorative design culture, fueled by a thriving economy. Will they coalesce into a new American aesthetic responsive to a decidedly modern lifestyle? Only time will tell.

new york

A city of skyscrapers, a world capital of finance, fashion, media, the arts, an enduring emblem of modernity, you would think that New York would be like Milan—a vibrant center for cutting-edge furniture design. It's not. For all New York's splashy style, it's only lately begun to generate a lively design culture. While a myriad of architects and designers have long made it their home, as a community they haven't always been immersed within the city's surging civic life and purpose.

Until recently, then, what contemporary furniture design there was in the city was generated within the recherché realm of decorator showrooms. Indeed, a long line of interior designers have contributed to a luxe, swanky, modern aesthetic that remains quintessentially, if nostalgically, New York: among them, Billy Baldwin and Tommi Parzinger in the Forties and Fifties; Ward Bennet, Joe D'Urso, Angelo Donghia in the Sixties and Seventies; and more recently, Jim Hutton, Bill Sofield, and Tom O'Brien.

The designers Dakota Jackson and Clodagh are also prominent within this world, but they are anomalies. Jackson is first and foremost a furniture designer and producer. Mass-manufacturing his urbane neo-deco furnishings in his own Long Island City factory, he's succeeded in almost single-handedly forging a small furniture industry in New York. Much of Clodagh's furnishings are limited-edition pieces created with artisans that take modern design in an unconventional, sensuously earthy direction. Distinguished as much of this work is—some of Jackson's pieces are in museum collections—it has seldom engaged the larger modern-design discourse. But then its stylistic intention has largely been to be decorative, not ground-breaking.

Outside of these showrooms, there haven't been many places to present contemporary design in the city, especially to the larger public. In the 1950s and 1960s, big-name retailers, including such department stores as Lord & Taylor, B. Altman, and Bloomingdales, carried contemporary furniture design. But with the advent of postmodernism, contemporary furniture became less commercially viable. Change didn't come until the mid-1990s, when the stores Moss and Totem once again made cutting-edge furnishings accessible.

That's why when contemporary furniture in the 1980s first reappeared on the city's cultural radar, it was not so much in shops as in galleries. It was a fitting venue. Contemporary design may not be a major industry in New York, but contemporary art is. And New Yorkers take notice of the gallery scene. Postmodernism had just turned contemporary design on its head, and a booming economy was giving taste sophisticates the excess cash to risk collecting something new. Many

New York designers are very attuned to the flux of fashion, its favored colors, textures, lines.

artists, frustrated with an increasingly slick art world, and intrigued by the aesthetic investigations of the postmodernists, turned their creative explorations to functional form. Galleries like Art et Industrie, Arc International, and Clodagh Ross Williams championed the resulting art furniture in all its diverse guises, from Alex Locadia's neoprimitive high-tech furnishings to Forrest Meyer's elaborate tangled-wire chairs.

The movement's startling forms and fresh vigor were seized by the media and helped stimulate government and commercial interest in cultivating a New York furniture industry. In 1989, the International Contemporary Furniture Fair (ICFF) was inaugurated. Although modest in size compared with the great contemporary-furniture shows of Europe, a global assortment of manufacturers, designers, and artisans were represented. Retailers, architects, designers, manufacturers, and the media came en masse for this surprising visual feast.

A watershed for contemporary American residential design, the ICFF has since become a citywide event, with top department stores organizing special window displays and shops and galleries putting on related exhibits. Many of the designers featured in this book—Harry Allen, Angela Adams, Denyse Schmidt, Ali Tayar, Ellen McLennan, Blu Dot, Abraxas—launched their furniture businesses at the ICFF and met crucial contacts. It's here, for instance, that Harry Allen was introduced to Murray Moss, a connection that later resulted in his creating the dazzling, all-white diorama-like interior for the landmark shop, Moss.

With the widening and maturing of New York's furniture design scene, a distinctive aesthetic is emerging.

The fanciful, freewheeling designs of the late 1980s and 1990s have given way to something harder-edged and retro-modern. But for all the allusions to designs of the midcentury, the work appears in earnest search of a vocabulary appropriate to a fast-morphing contemporary lifestyle. What does modernism mean in a high-tech world, where industrial methodologies that once helped inform the movement have all but become obsolete? With laser fabrication, for example, all kinds of designs can be factory-produced, and digital technologies have even made it possible to program randomness into mass production runs.

Interestingly, a number of these designers cite the fashions of Helmut Lang as inspiration. He's boldly sought to develop a fresh fashion vocabulary for a high-tech age, experimenting with silhouettes and textiles that speak of the moment. More than elsewhere in the country, New York furniture designers are quite attuned to the flux of fashion, its favored colors, textures, lines. Not only is it a defining part of their urban culture, but many also do interior work for fashion designers and retailers. So, in many respects, it is their bread and butter.

Although decidedly modern in their style, in their proclivity to question, these New York designers share much with the art-furniture creators who came before them, as well as with Italy's bad-boy postmoderns—Ettore Sottsass, Andrea Branzi, Alessandro Mendini, Gaetano Pesce. In fact, Constantine Boym, Laura Handler, and Karim Rashid are among a number of those who studied under or worked for those fabled Italians. Several others, including Nick Dine, Marre Morel, David Weeks, and Lloyd Schwan, came to furniture design directly from the art world.

Whatever their backgrounds, an interaction with the art world seems invigorating and necessary to their work. Boym developed his "Sears Style" furnishings with the conceptual artists Kolomar & Melamid as part of a larger movement committed to examining this uniquely banal, American aesthetic. His new furniture line further investigates the design possibilities of ordinary objects, this time commonplace industrial ones. Similarly, Nick Dine, attracted by the anonymity and universality of everyday industrial objects, like Grainger carts and John Deere tractors, has sought to develop furnishings based on these forms. Ross Menuez claims that the inspiration for all his designs comes from the McMaster-Carr catalogue.

Much of this work is as appropriate to the gallery as the store. Indeed, a growing number of New York artists, such as Andrea Zittel, Tom Sachs, and Angela Bulloch, are exploring furniture and product design as conceptual art.

Like artists, what drives many of these designers is having their vision realized, not necessarily having it mass-produced. Much of the work featured is at best available in limited editions, with most of the designers looking to Europe and Asia for manufacturers. Their international focus reflects not only the realities of the contemporary furniture business, but also their own makeup as a community. Many of these "New York designers" actually hail from all over the globe: Karim Rashid is Canadian, Ali Tayar is from Turkey, Constantine Boym from Russia, and Marre Morel from the Netherlands.

While manufacturers for contemporary furniture are scarce in the States, and especially New York, there are more now than there were ten years ago. Dennis Miller's showroom has been a leader, commis-

sioning since the late 1980s the manufacture of the furnishings of a select assortment of contemporary American designers, including Clodagh, Harry Allen, and Matthew Hooey. More recently though, ICF, the New York–based importer of modern classics, has begun producing a line of furnishings by Ali Tayar. George Kovacs, once a leader in contemporary lighting manufacture, has again become adventurous in commissioning, with new products from Karim Rashid and Harry Allen. But it's been Totem that has been a galvanizing force for this community, not only producing, but also promoting and marketing the designs of still-unknown talents.

Since most of these designers content themselves with making prototypes or limited-edition production lines, they need to pursue parallel careers as industrial or interior designers in order to pay the rent, creating in their other incarnations everything from clever cosmetics packaging to trendy boutiques. With Waterloo and Pop, Tayar has created two of the city's most inventive restaurant interiors; Dine has designed the hip boutiques Zao and Kirna Zabête; and Lloyd Schwan has masterminded the monochrome, midcentury-design shop Form and Function. Ross Menuez recently moved to London to be the furniture style coordinator for that early design-retailing bellwether Habitat. Meanwhile, Karim Rashid is designing everything from a cosmetics line for Prada to the Armani boutique in Soho. Their names, however, are seldom linked to these projects. While furniture designers in Europe are promoted as stars, these talents have yet to achieve celebrity status in the States.

But that may be changing. In 1999, Rashid was featured in *New York* magazine as a leading New Yorker. He was also selected by Con Edison, the city's utility company, to create a special-edition manhole cover to celebrate the new millennium. Adorned with trippy moiré graphics, these covers were installed with much fanfare around Times Square for New Year's night. It was a banner event. After so long being outside the city's everyday life, contemporary design was at long last merging with the very streets of New York.

CHECKERS CHEST
Lloyd Schwan
painted and stained wood, powder-coated steel

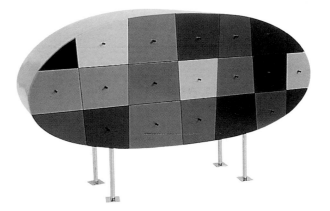

"I define my work as **sensual minimalism**, where objects communicate, engage, and inspire yet remain fairly minimal. My work is a marriage of the organic juxtaposed with pure geometry, as a motivator of human engagement."

—KARIM RASHID

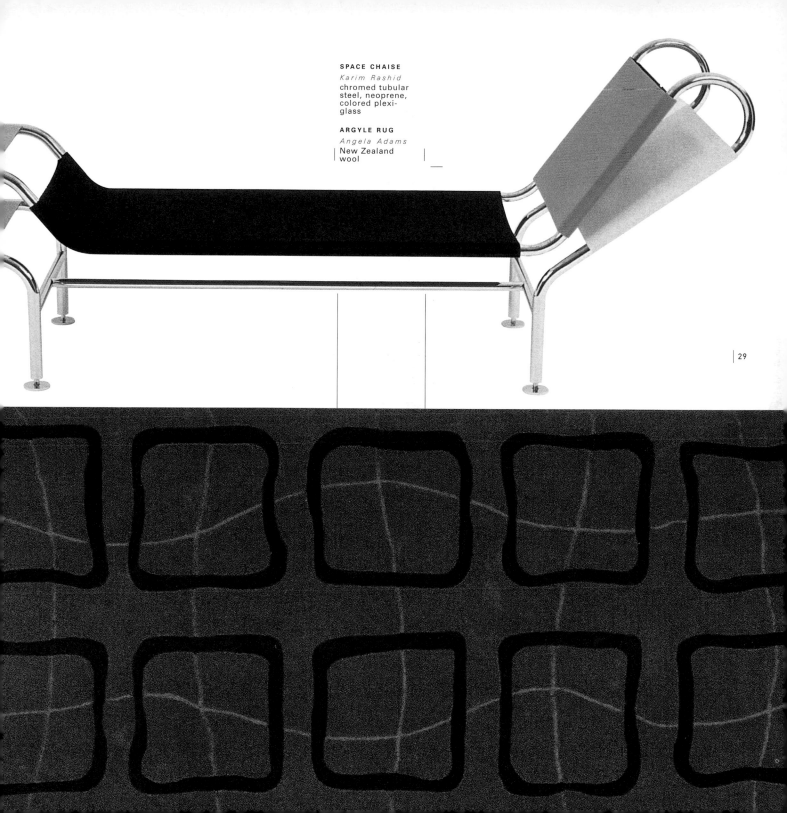

SPACE CHAISE
Karim Rashid
chromed tubular
steel, neoprene,
colored plexi-
glass

ARGYLE RUG
Angela Adams
New Zealand
wool

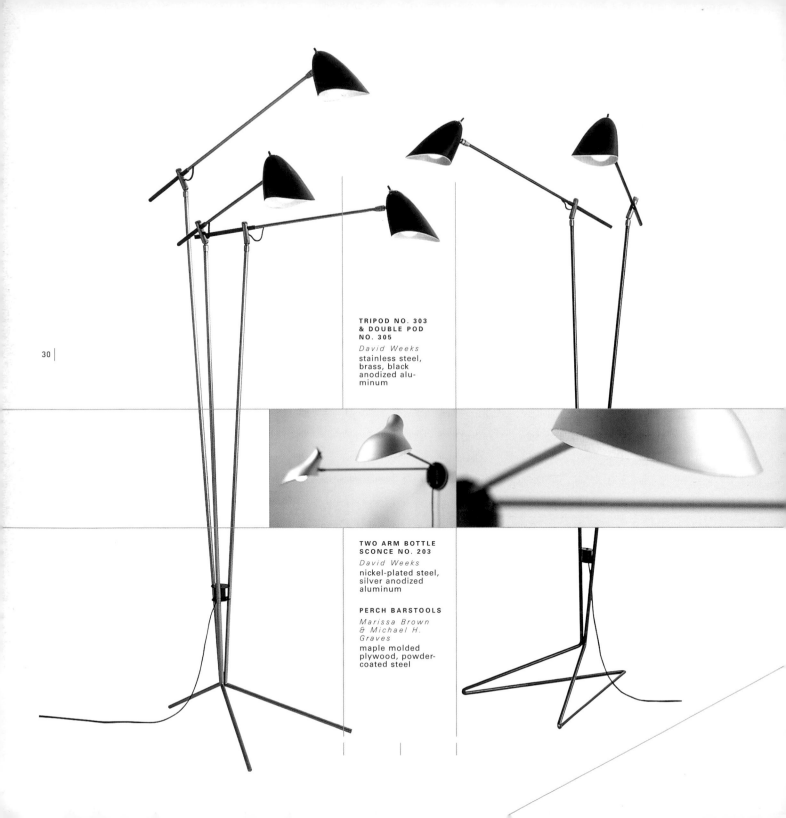

**TRIPOD NO. 303
& DOUBLE POD
NO. 305**
David Weeks
stainless steel,
brass, black
anodized alu-
minum

**TWO ARM BOTTLE
SCONCE NO. 203**
David Weeks
nickel-plated steel,
silver anodized
aluminum

PERCH BARSTOOLS
*Marissa Brown
& Michael H.
Graves*
maple molded
plywood, powder-
coated steel

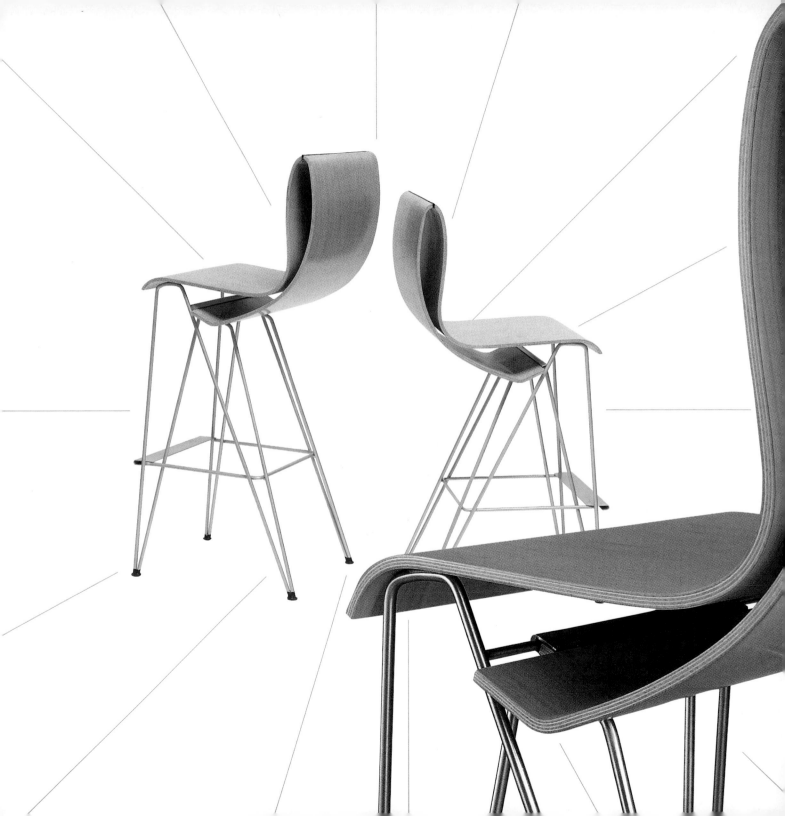

IRKLE SHELVES
Lloyd Schwan
lacquered wood

SCREEN 2
David Khouri
lacquered
acrylic

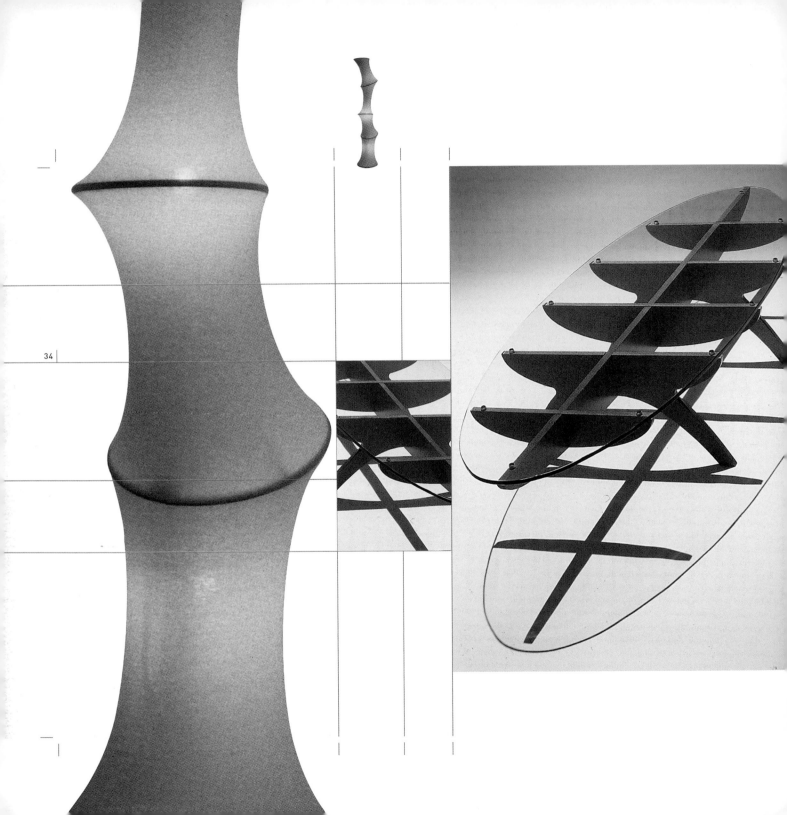

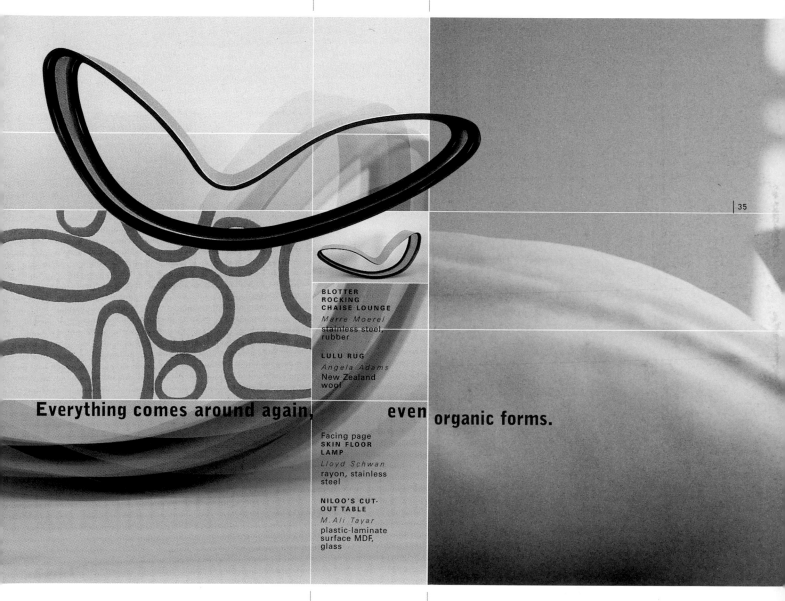

**BLOTTER
ROCKING
CHAISE LOUNGE**

Marre Moerel
stainless steel,
rubber

LULU RUG

Angela Adams
New Zealand
wool

Facing page
**SKIN FLOOR
LAMP**

Lloyd Schwan
rayon, stainless
steel

**NILOO'S CUT-
OUT TABLE**

M. Ali Tayar
plastic-laminate
surface MDF,
glass

Everything comes around again, even organic forms.

**SPLINE
ARMCHAIR &
ELECTROLYTE
LAMP/SHELF**

Karim Rashid
chromed steel,
wool uphol-
stery; powder-
coated steel,
translucent
plexiglass

WINK 38 TILES
Jeff Gross
molded
polyurethane

36

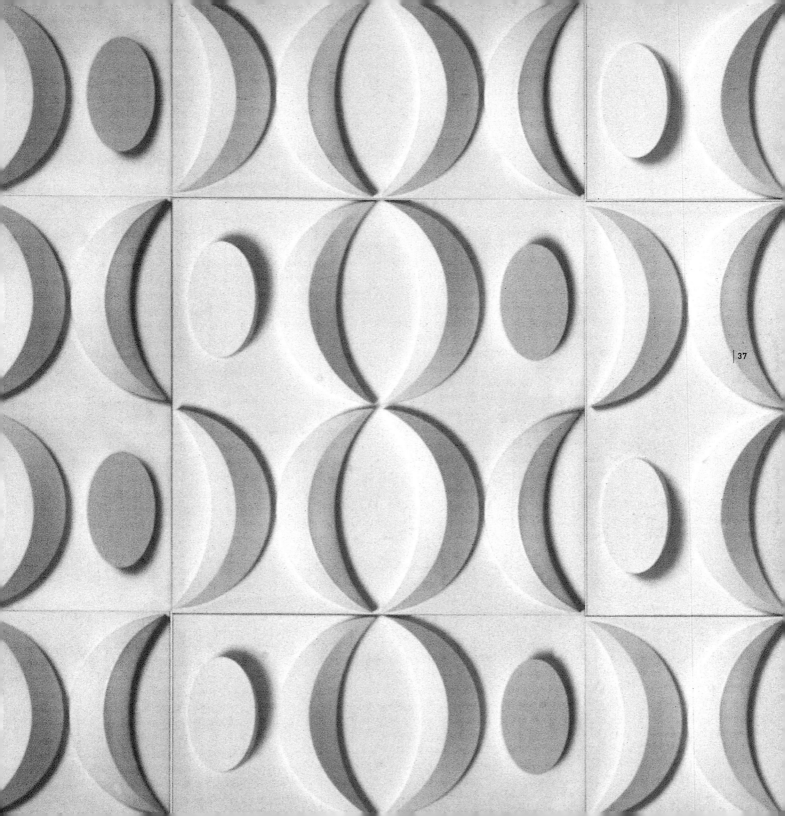

As a designer, I've had a long interest in looking at everyday, conventional objects and trying to figure out new and unusual ways to interpret them. It's a diffi-cult and challenging task to reinterpret such objects.

—CONSTANTIN BOYM

Facing page
**HUSBAND
ARMCHAIR**
*Constantin
Boym*
**ready-made
cushion, wood**

STRAP CHAIR
*Constantin
Boym &
Laurene Leon
Boym*
**wood frame,
packing straps**

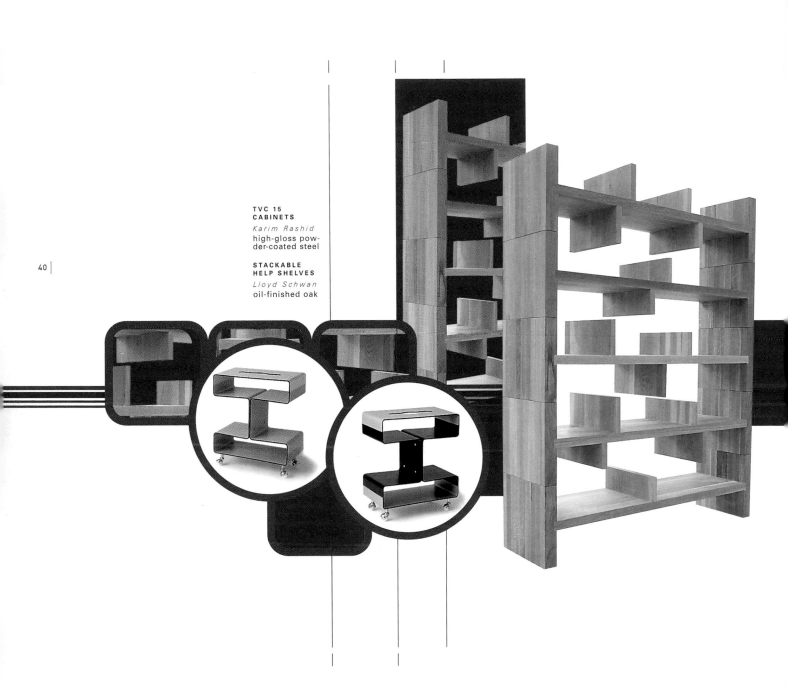

TVC 15
CABINETS
Karim Rashid
high-gloss pow-
der-coated steel

STACKABLE
HELP SHELVES
Lloyd Schwan
oil-finished oak

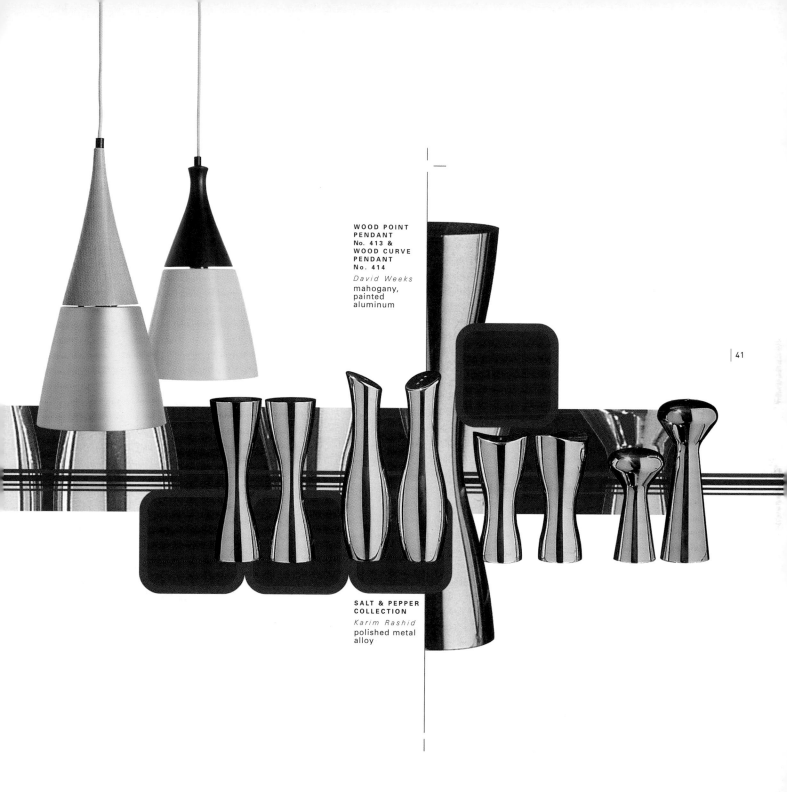

**WOOD POINT
PENDANT**
No. 413 &
**WOOD CURVE
PENDANT**
No. 414
David Weeks
mahogany,
painted
aluminum

**SALT & PEPPER
COLLECTION**
Karim Rashid
polished metal
alloy

VIRTUAL DINER
Joseph Boron
chromed steel,
glass

SKELETON
CHAIR
Lloyd Schwan
chromed steel

TABLES
Chad Jacobs
powder-coated
steel, plywood

Structural expression remains quintessentially modern

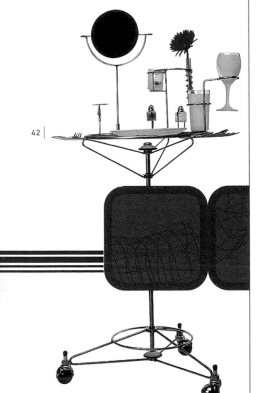

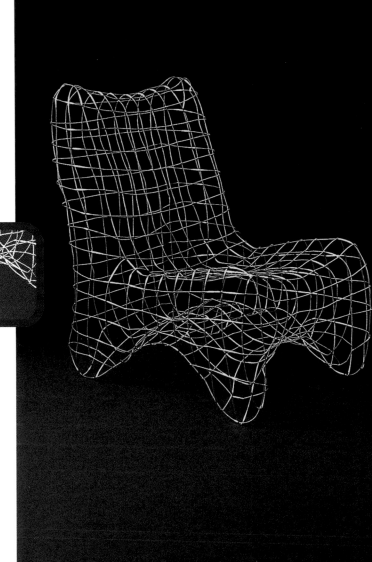

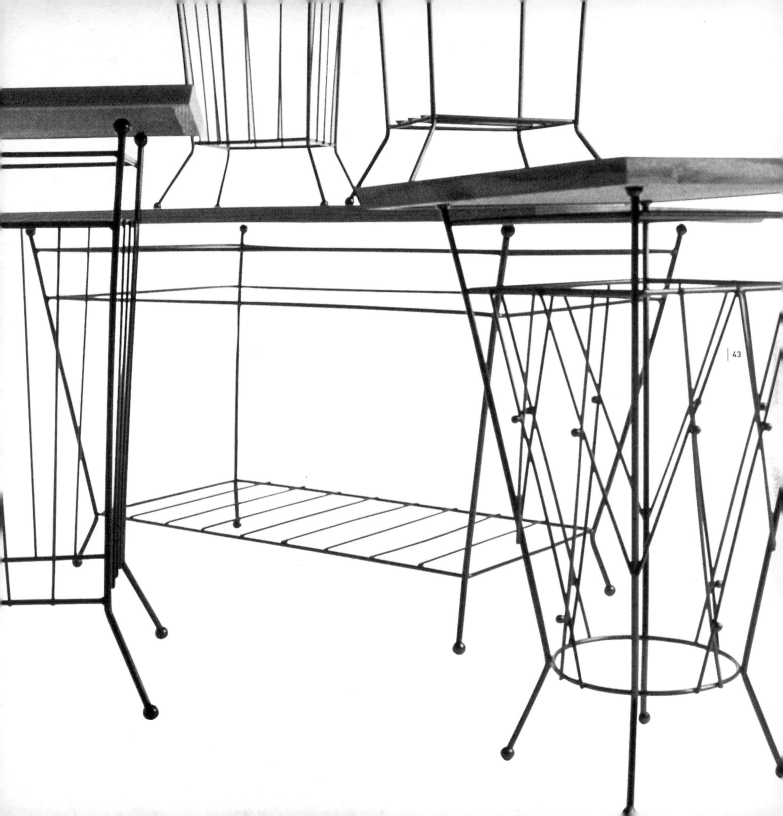

**STRIPE
COLLECTION**
*Jonathan
Adler*
ceramic

**GRID SIX
CABINET**
Michael Solis
frosted glass,
powder-coated
steel, wood,
rubber

DOCZI LAMP
Ross Menuez
nylon

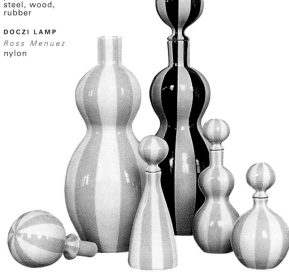

DOMINO SOFA
Ross Menuez
stainless steel,
foam

Pages 48–49
**PEARCE/QUINN
LOFT INTERIOR**
*Morris/Sato
Studio*

46

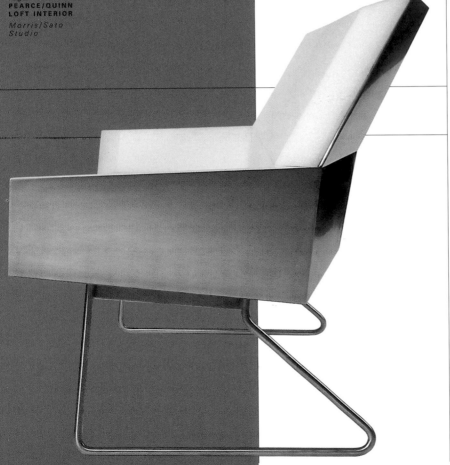

With **new technologies,**
steel can be bent
with the elegance of.
origami

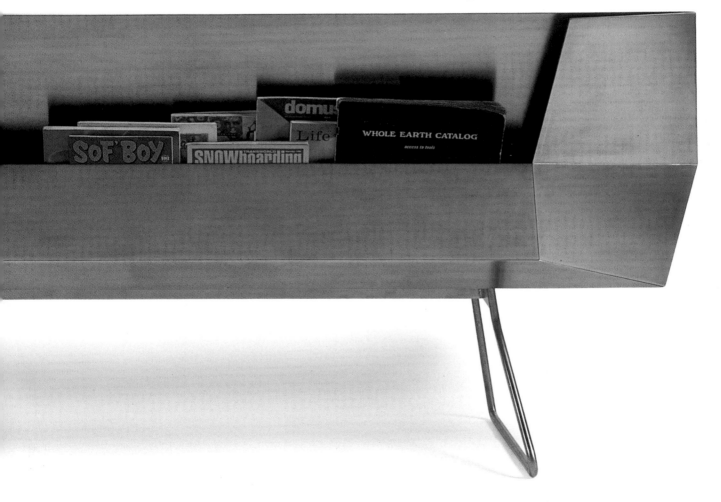

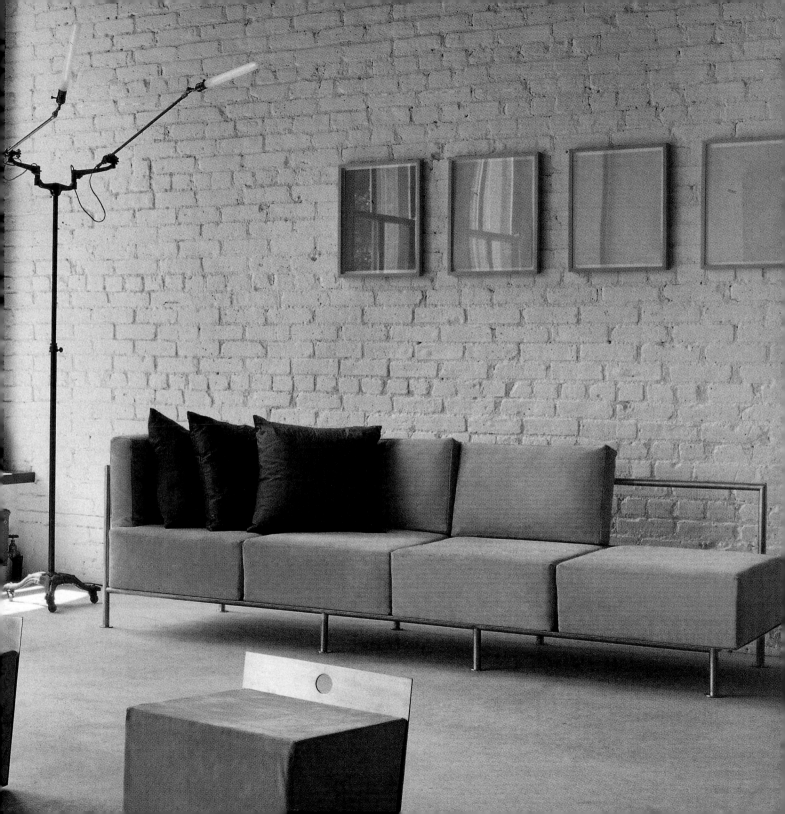

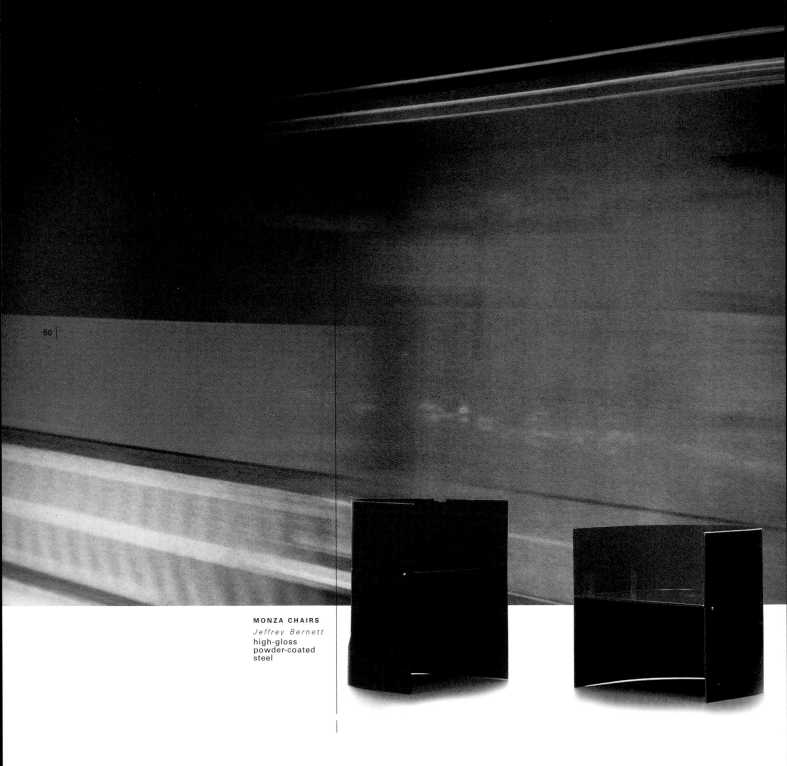

50

MONZA CHAIRS
Jeffrey Bernett
high-gloss
powder-coated
steel

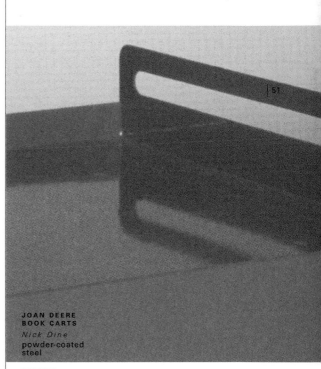

"The good thing about being a furniture **designer in New York** is the community is small. If I were in Milan, I'd be one of five billion. But there's no real structure. It's not like the art world. You have to invent your career."

—NICK DINE

| 51

**JOAN DEERE
BOOK CARTS**
Nick Dine
**powder-coated
steel**

SCREEN
Stephen Burks
enameled steel

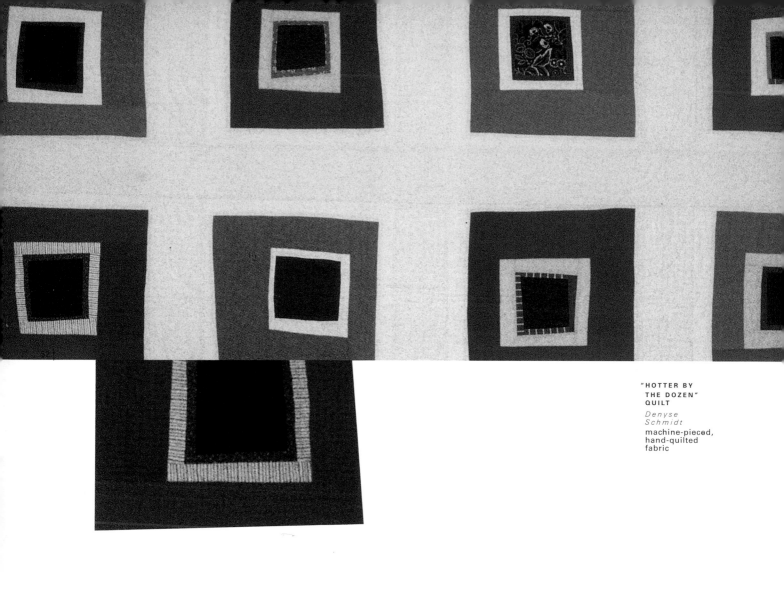

"HOTTER BY THE DOZEN" QUILT

Denyse Schmidt
machine-pieced, hand-quilted fabric

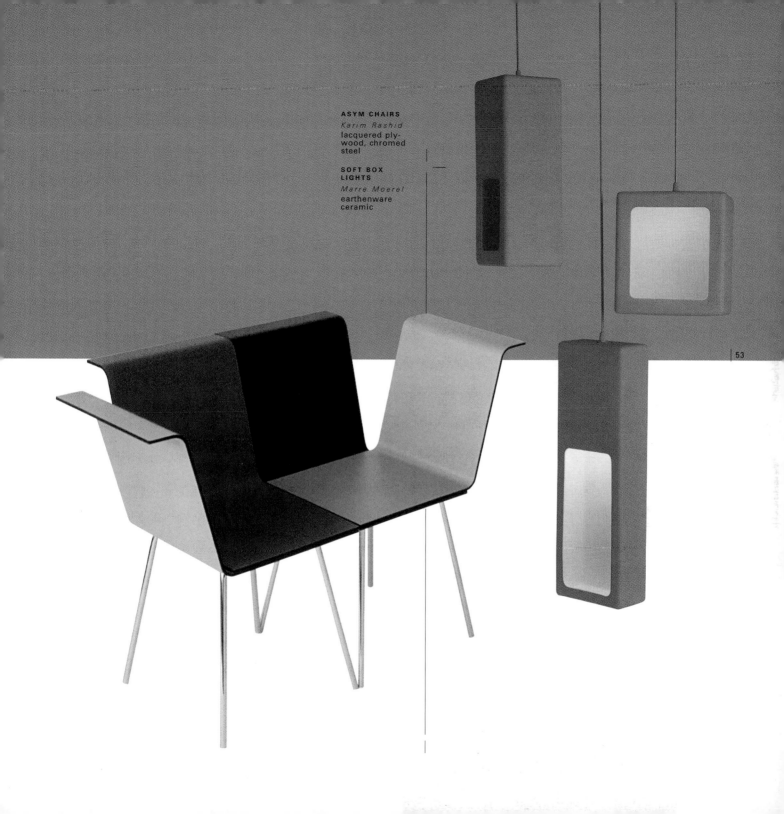

ASYM CHAIRS
Karim Rashid
lacquered plywood, chromed steel

SOFT BOX LIGHTS
Marre Moerel
earthenware ceramic

53

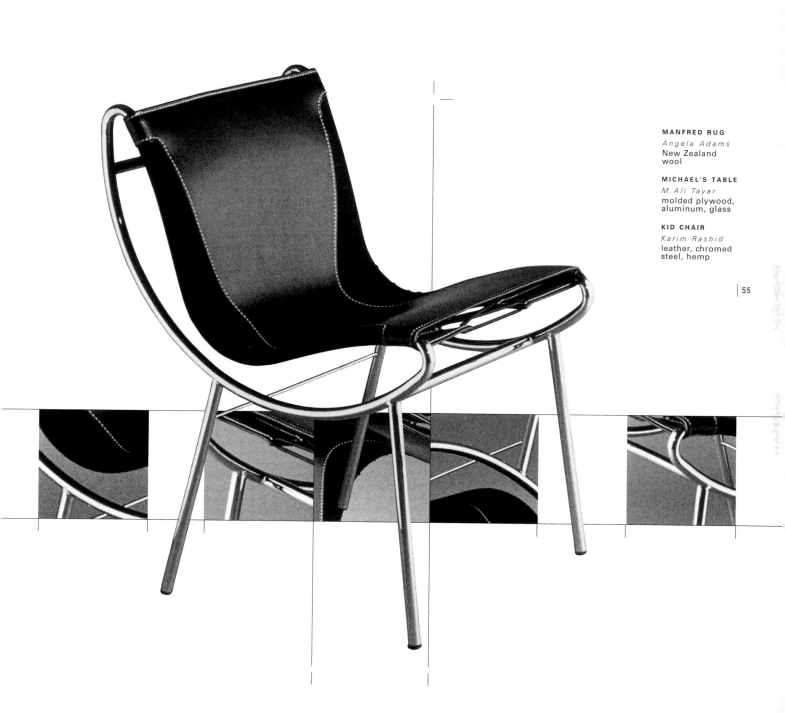

MANFRED RUG
Angela Adams
New Zealand
wool

MICHAEL'S TABLE
M.Ali Tayar
molded plywood,
aluminum, glass

KID CHAIR
Karim Rashid
leather, chromed
steel, hemp

55

ZELPHA TABLE
David Khouri
stainless steel

**LOVEME
COCKTAIL
TABLE**
David Khouri
lacquered
wood, stainless
steel

Even the simplest forms offer a
multiplicity of **variations**

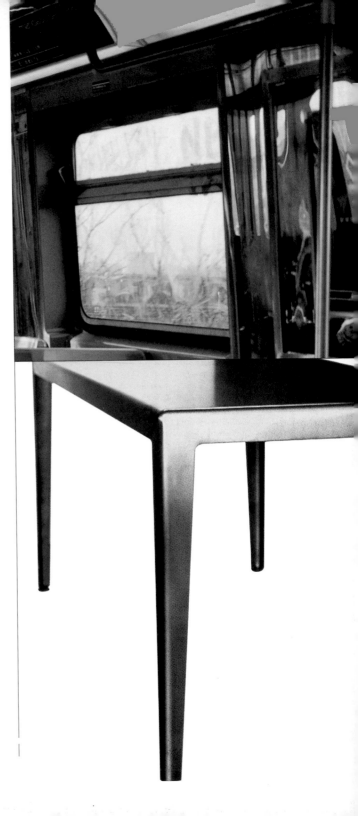

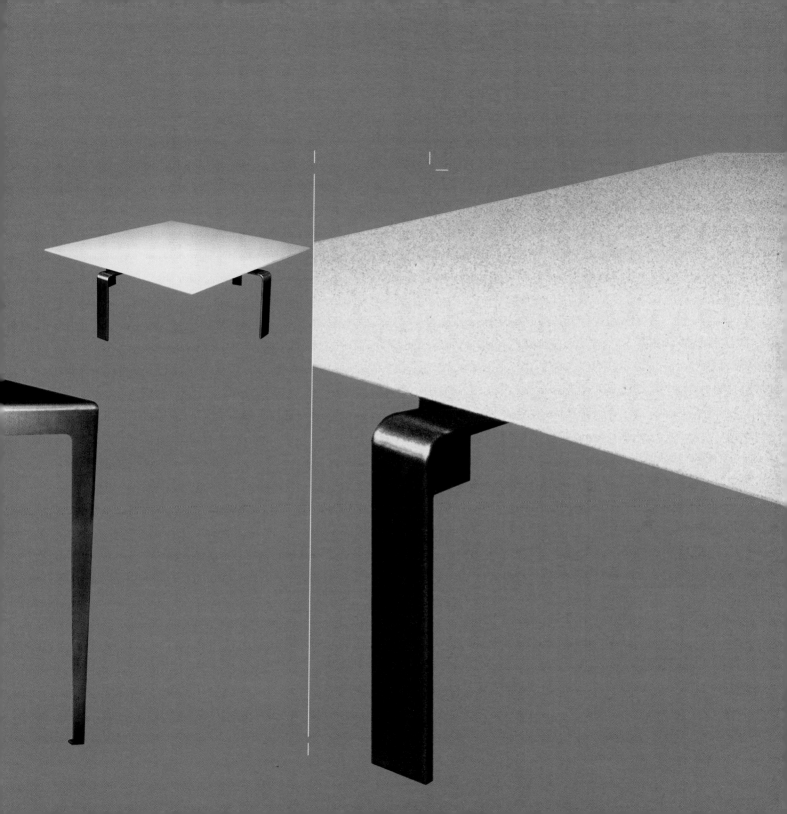

**VANILLA FUDGE
LOUNGE**

Ross Menuez
stainless steel,
nylon

FLEXION LAMPS
Chad Jacobs
polypropylene

POINT REY SOFA
Nick Dine
neoprene, steel

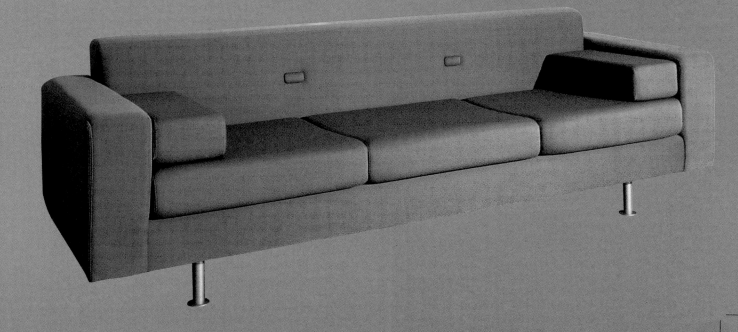

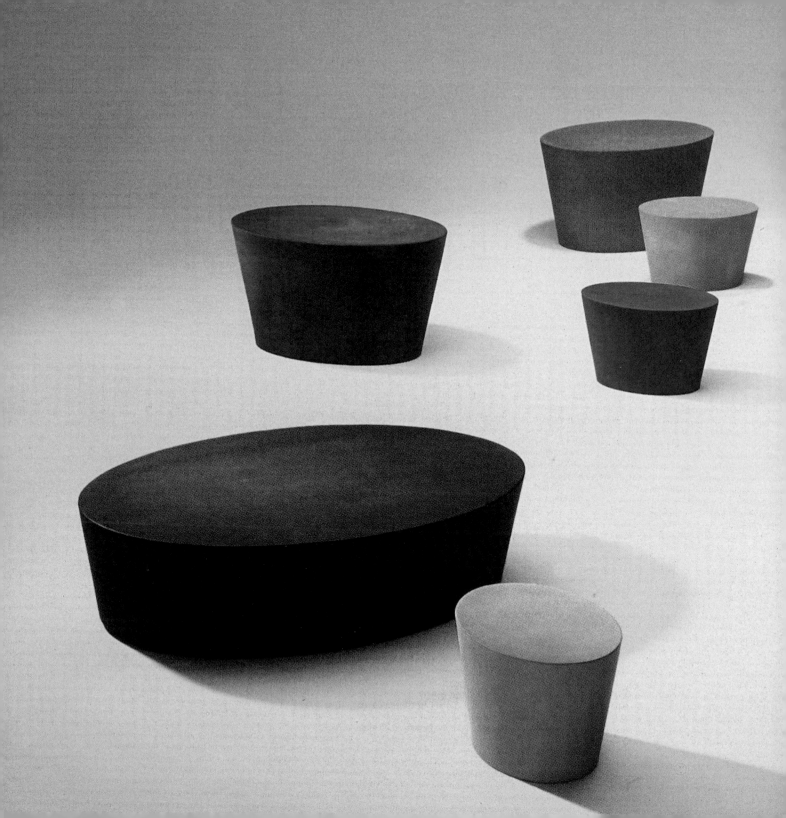

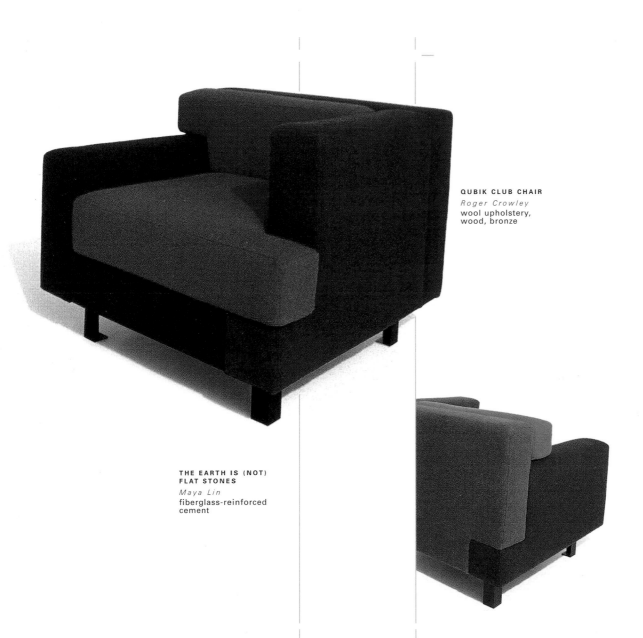

QUBIK CLUB CHAIR
Roger Crowley
wool upholstery,
wood, bronze

**THE EARTH IS (NOT)
FLAT STONES**
Maya Lin
fiberglass-reinforced
cement

**MARY JANE
CONSOLE**

David Khouri
cast resin, alu-
minum, honed
marble

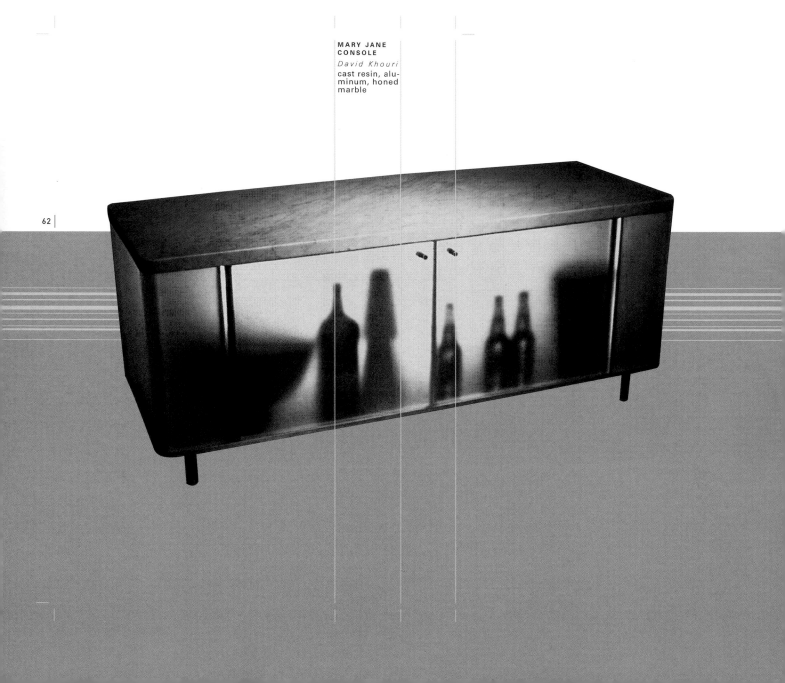

**VALET OF THE
DOLLS TABLE**
David Khouri
cast polyester
resin, acrylic

Transparency
is the material of
tomorrow

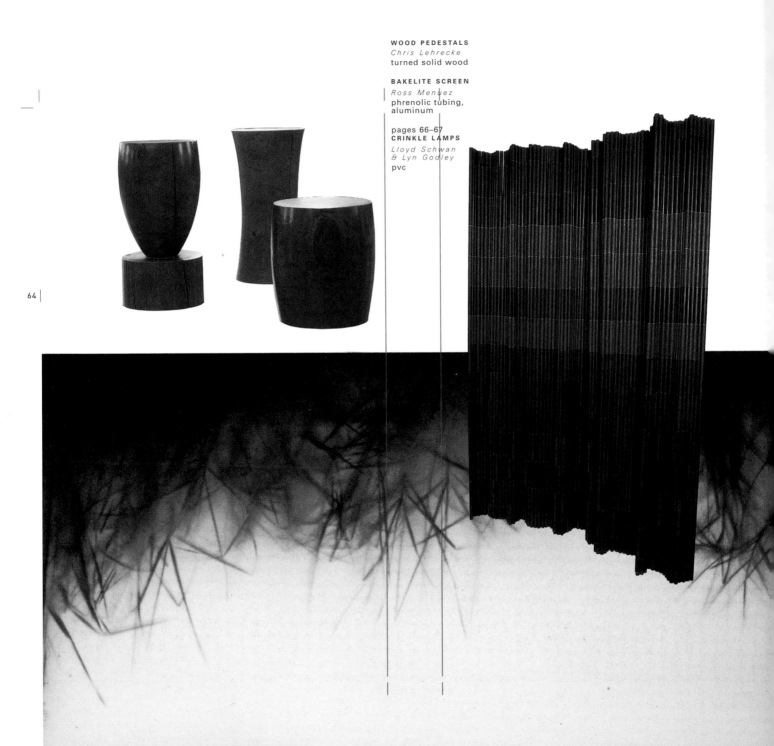

WOOD PEDESTALS
Chris Lehrecke
turned solid wood

BAKELITE SCREEN
Ross Menuez
phrenolic tubing,
aluminum

pages 66–67
CRINKLE LAMPS
*Lloyd Schwan
& Lyn Godley*
pvc

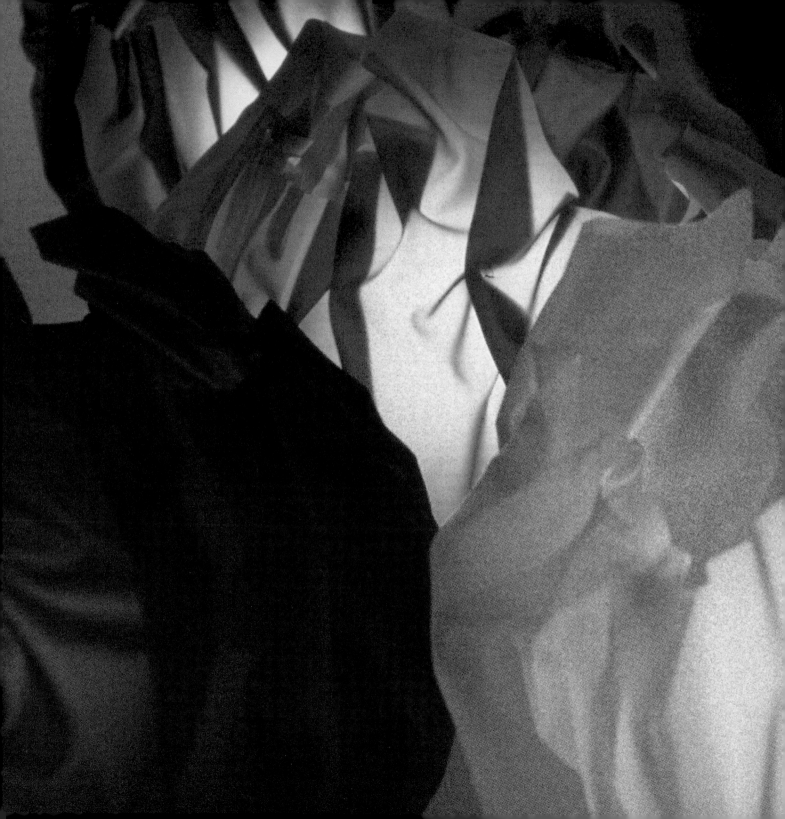

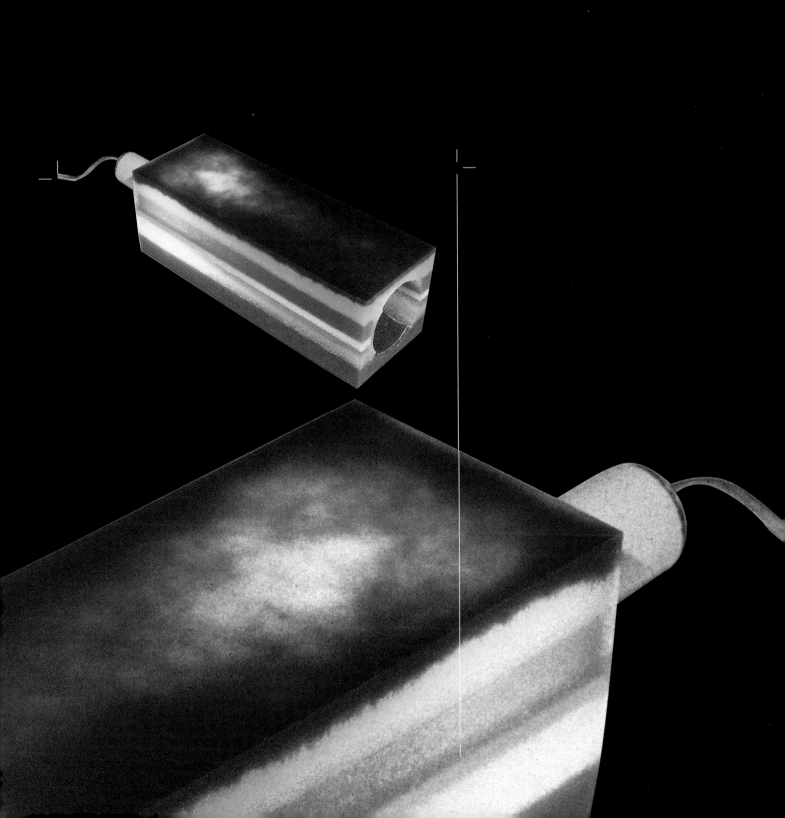

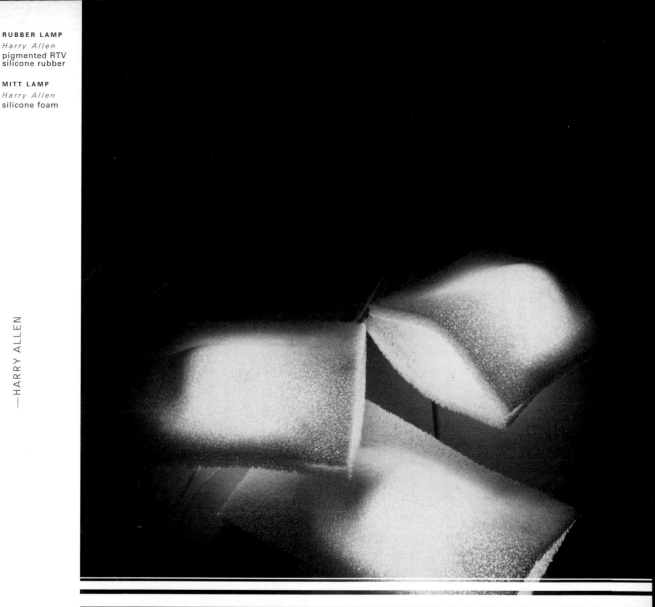

"I believe the best design comes from life experiences, not a design education. At the theater, watching a play, I've suddenly been struck by the lighting and have a thought, wouldn't it be nice to do something like that in a room?"

—HARRY ALLEN

RUBBER LAMP
Harry Allen
pigmented RTV
silicone rubber

MITT LAMP
Harry Allen
silicone foam

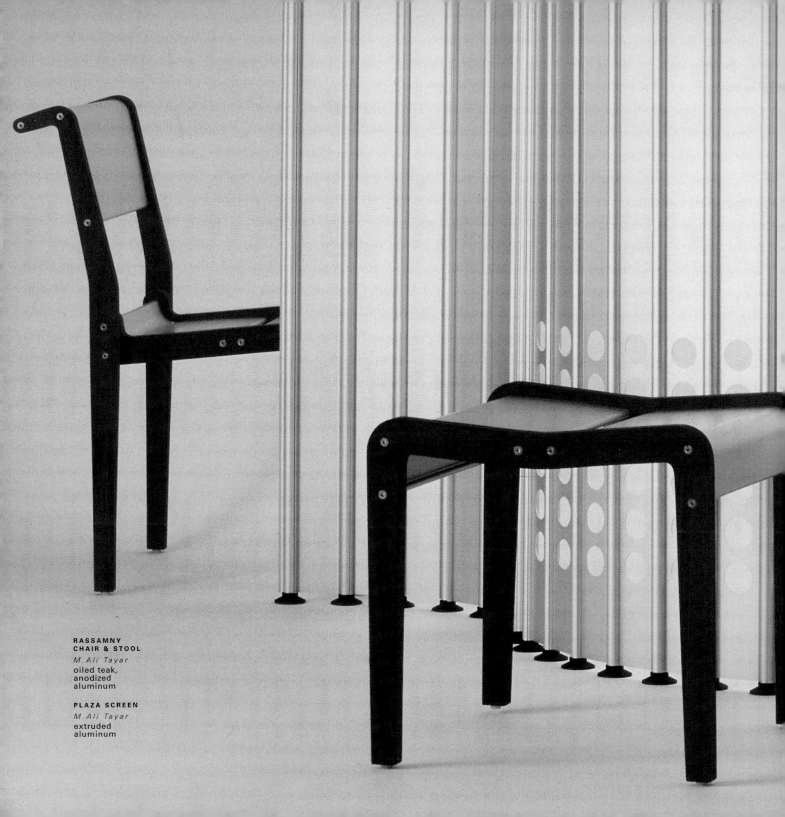

**RASSAMNY
CHAIR & STOOL**
M. Ali Tayar
oiled teak,
anodized
aluminum

PLAZA SCREEN
M. Ali Tayar
extruded
aluminum

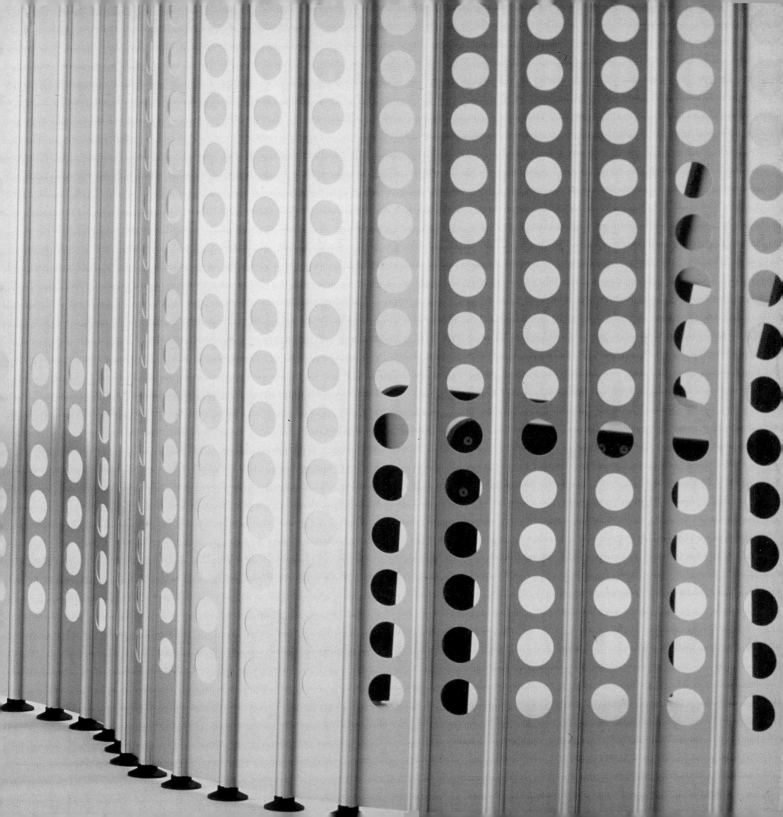

I was born in Istanbul, and raised there. I went to middle school in Germany and to university in Stuttgart, and got my Master of Architecture from MIT. I came to New York after that, and worked for an engineering firm in the architecture department, where I designed airplane hangars for the Air Force. Then I joined a small architecture firm, specializing in tensile structures. In 1992, I started my own firm during the depths of the recession, when everybody was losing their jobs. I started it then partly because I had such a specialized background, I wasn't sure anyone would hire me. I turned to furniture early on in my practice because I felt I could treat it like a piece of structure. I could apply everything I had done in architectural projects—work with the same structural engineers, the same manufacturers. It was much smaller scale, so it was doable in terms of time and budget.

Just at that time, I got a commission to do a loft for a writer friend of mine, and I designed a special shelving system for her books, which I later named "Ellen's Brackets." It was a pure cantilever system—I worked on it with a structural engineer—and I approached it as a structural problem. It got me into the *Mutant Materials* show at the Museum of Modern Art, which made sort of dabbling in furniture more serious for

m. ali tayar

me. Since then, I've been adding a couple pieces a year for the last eight years.

My father was a structural engineer, which is why I've always been drawn to engineering. Frei Otto, who is sort of the German Buckminster Fuller, is the reason I studied architecture. When I saw his work I realized architecture could be based on engineering. That intrigued me, that idea of expressive structure. There are two aspects of my architectural work: one is pure structural design, the other is standardized design. In my furniture I combine those two: on the one hand, the pieces are structurally expressive; on the other, they are, at least in concept, mass-produced. These are somewhat contradictory goals, since structural expression implies organic shapes, and unless you go to casting or injection-molding, those shapes are difficult to manufacture. So you have to find other methods that give you implied organic shapes, like bending, folding, laser-cutting, and extrusion.

Laser-cutting has really changed everything for me. In one restaurant I designed, called Pop, there's this

ceiling system that is laser-cut. It's a production run of two hundred boxes that are all laser-cut and powder-coated, and were specifically manufactured for the restaurant. It would have been impossible five years ago to make a production run like that. The change is due to the advancement of computer technology.

There are many aspects of the city that influence me. My office is in the meatpacking district, and there's a lot of moving and storage places here, and you see these skids around everywhere. So I got a grant from the NEA to investigate molded particleboard. The idea came to me purely by being in this neighborhood. The Gansevoort Gallery gate was the same thing. In a neighborhood full of all these meat conveyors comes this high-modernist furniture gallery. So I designed the gate to reflect all the stuff that's around.

In my furniture I combine those two aspects of my architectural work: on the one hand, the pieces are structurally expressive, on the other, they are, at least in concept, mass-produced.

The beginning of my generation's work was kind of the end of postmodernism. So everybody kept thinking that when the mood changes, we'll all be put into production. Right now, it's easier to get into museum exhibits than to get work into production. I always thought the reverse would be true. So there are all these contemporary American furniture shows going around, and yet there is no production behind any one of these pieces. I hope that changes.

73

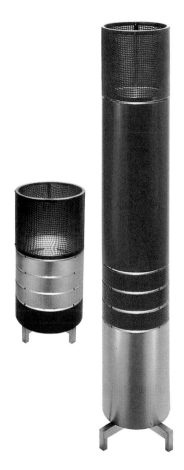

**STACKING TABLE
LAMP & FLOOR
LAMP**

*Stuart
Basseches*
powder-coated
aluminum,
anodized alu-
minum, steel
mesh

"TING"
SERVERS
Hannah Brand
low-fire ceramic

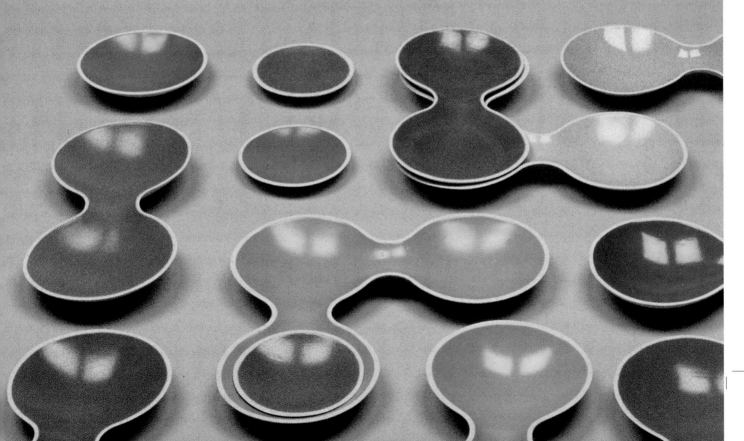

facing page
**TV-TIME THROW
CUSHIONS**
David Khouri
urethane,
walnut

I'm happy with a very square chair, just calm, **simple geometry.**

I'm such a functionalist.

There's room for humor and play there, it doesn't
need some great form. It's the thought underneath that makes the design good."

—HARRY ALLEN

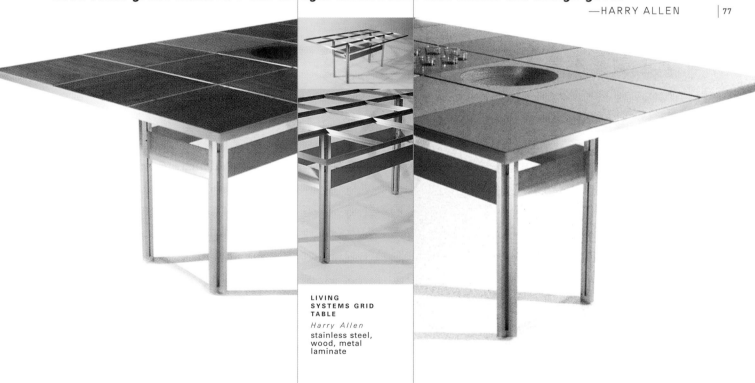

**LIVING
SYSTEMS GRID
TABLE**

Harry Allen
stainless steel,
wood, metal
laminate

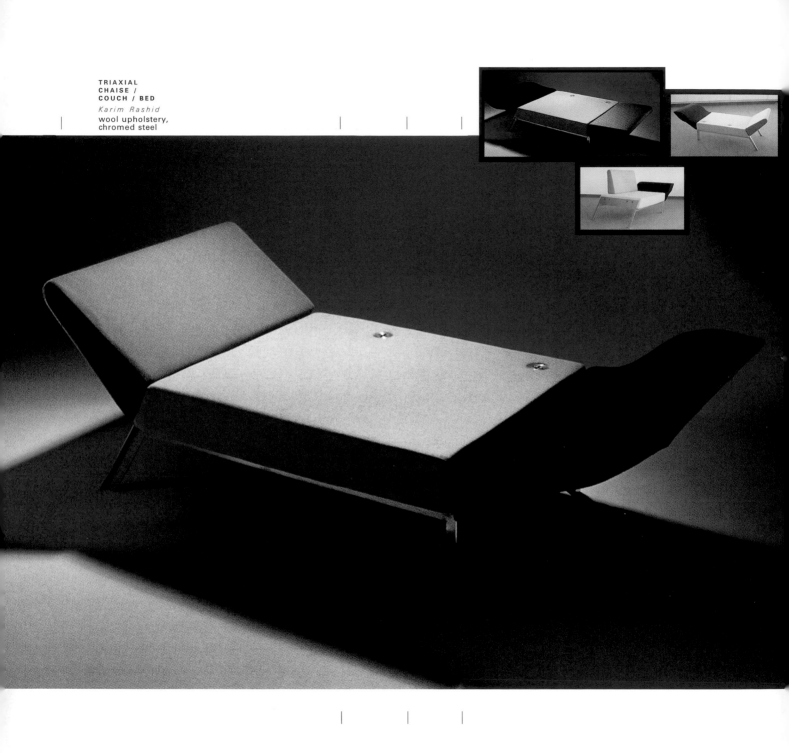

TRIAXIAL CHAISE / COUCH / BED

Karim Rashid
wool upholstery, chromed steel

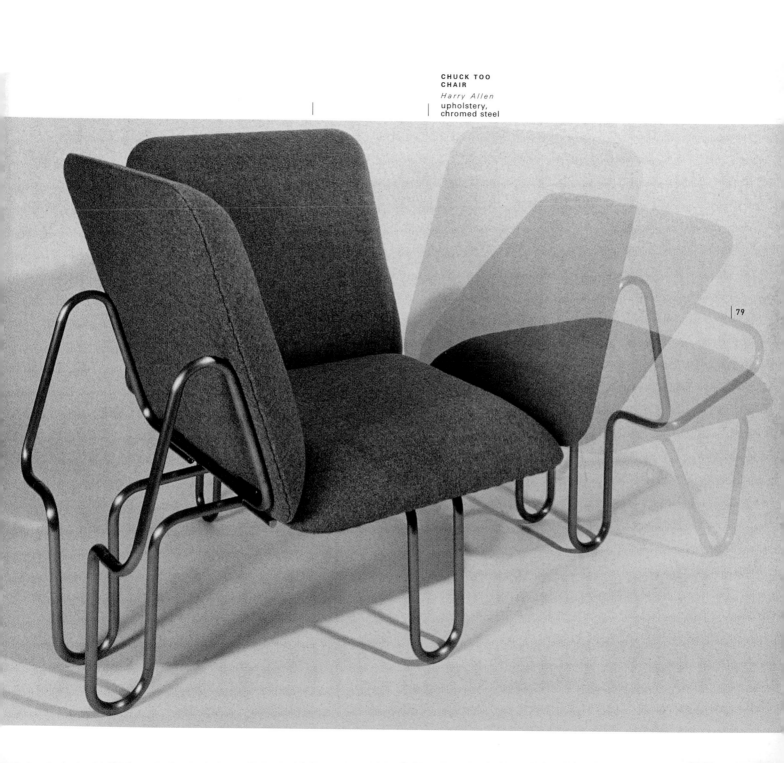

**CHUCK TOO
CHAIR**
Harry Allen
upholstery,
chromed steel

79

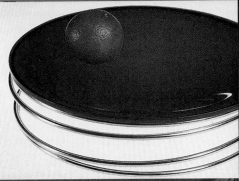

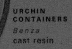

**URCHIN
CONTAINERS**
Benza
cast resin

BOING DISH
Benza
acrylic, stain-
less steel

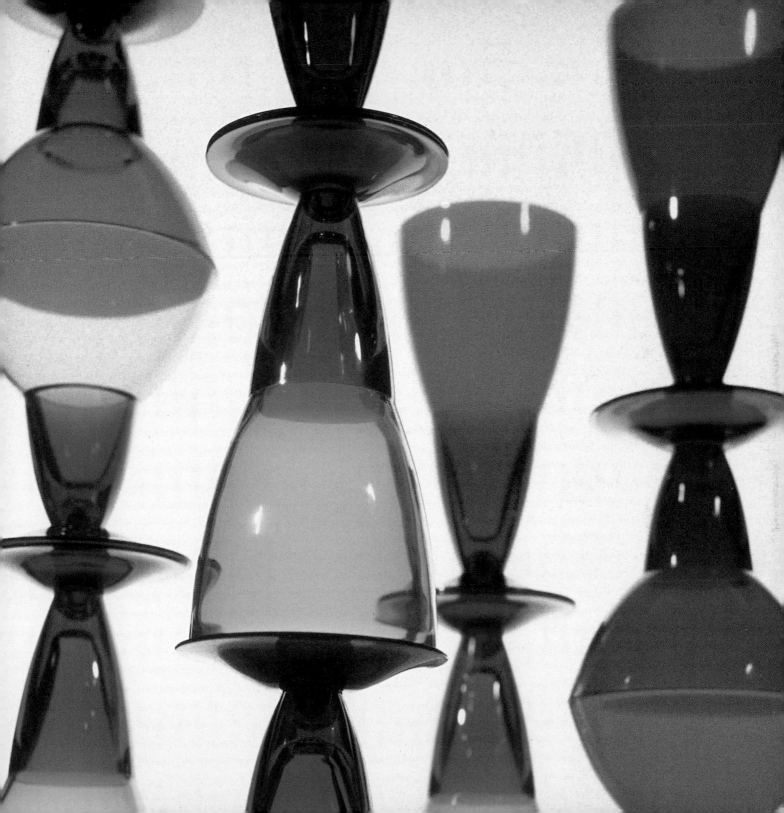

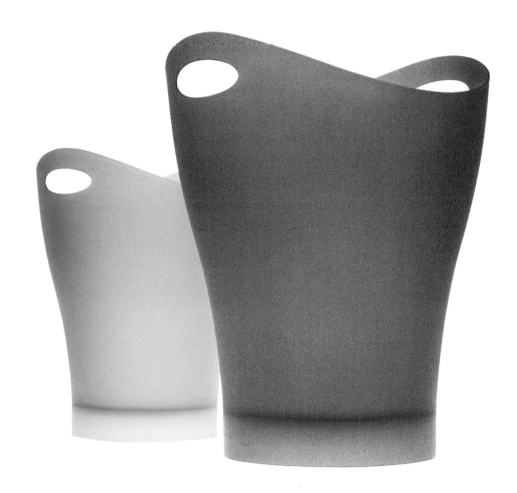

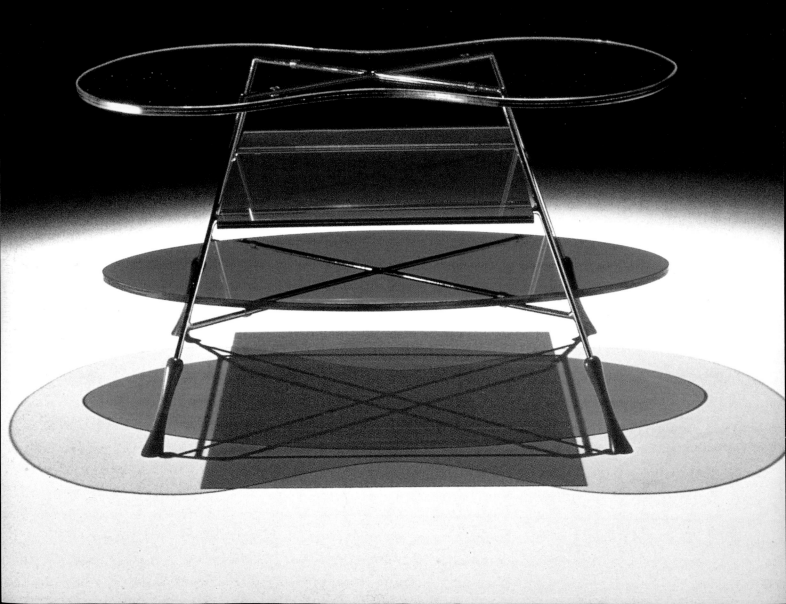

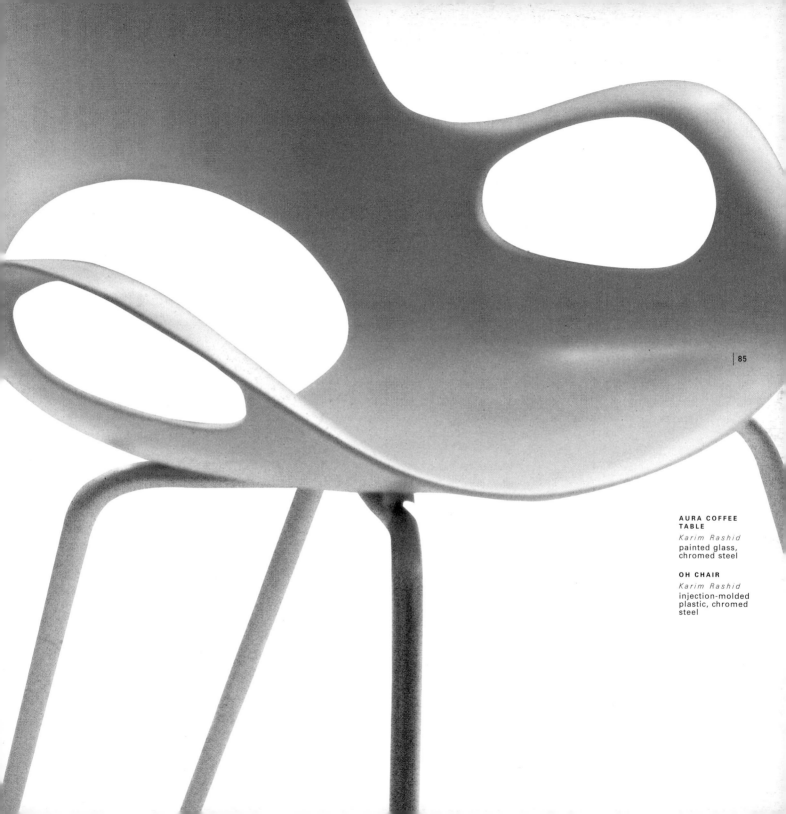

AURA COFFEE TABLE

Karim Rashid
painted glass, chromed steel

OH CHAIR

Karim Rashid
injection-molded plastic, chromed steel

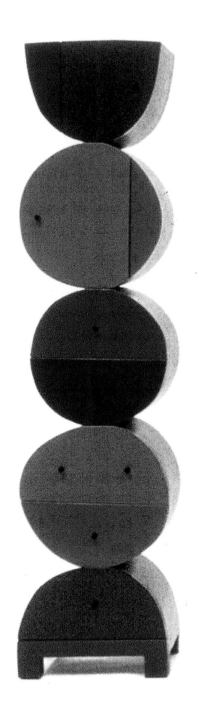 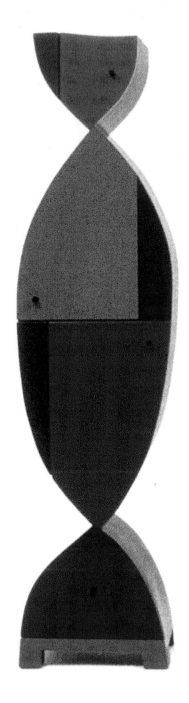

DANCER
CABINETS
Lloyd Schwan
painted &
stained wood

I come from both the tradition of modernism and from art furniture. I'm pretty hard to place in a category, and at times people are a little uneasy. The Italians simply say, "You're an artist." It's hard to remove that, and I don't even try. It gives me a certain freedom. I'm not trying to be the most known designer. I'm grateful to be able to do what I do and get paid for it, so I can do more of it, which is every artist's dream. I've been doing this for close to twenty years, and I'm still excited about it.

I don't spend a lot of time thinking about what I do. I spend time thinking about why I did what I did, and where I'm going in that sense. I don't paw through magazines looking at other people's work trying to figure out where I fit in. My work is driven by just my need to make art, more so than external forces. I've had a need to make art since I was three and started drawing in a big way. I've never stopped. My connection to the outside world, and being a designer, is influenced by the people I work with. My connection with my clients, whether positive or negative, is always incredibly important. The difference between being an artist and a designer is that I collaborate. As I've matured—or gotten

older, however you want to look at it—that collaboration has become more intriguing and interesting. It has taught me to let go. It doesn't always have to be generated by me. If we work together, you and I become another entity. Separately, I'm isolated, which is the difficulty of just making art. It's almost a non-verbal communicating, developing images together.

As a designer, I don't always express myself verbally. There's this other thing that happens, which is interesting, because it's always misinterpreted. People always thought of my early work, "Oh, there's a lot of color, you must be happy." I would say that those were some of the darkest times. People are always looking, they want something from personal work. Often it's impossible to share. Their experience is going to be something entirely different from yours. My background as an artist helped me understand that. The public, the reviewers have other interpretations. My most recent work is more minimal, so people don't try to figure it out as much. The point is the work is very personal, and it's very hard to share that with a lot of people.

The group with whom I merged when I came to New York were a tad older, and they were artists. They didn't come from design schools per se, or even if they did, the main focus of their work was art. The people with whom I sit down today are designers. I have interns, with whom I love working, but when I ask them, "You know that Carl André piece?" They go, "Huh?" It's a design community now, but not a design community that has its roots in the art world. I sort of straddled both worlds, and so one kind of evaporates and the other takes hold. It's not for better or worse, it's just logical. This one is able to work with manufacturing, and has a different discipline. The other was very much undisciplined, very interesting. A lot more colorful characters back then than there are today. It's hard to imagine I've lived through a couple generations of design community in the past fifteen years.

I'm an American; I don't have any desire to live in Europe. New York is a culture that I understand. You don't have to explain yourself here. There's a community of designers, clients, an accessible community of

The difference between being an artist and a designer is that I collaborate. As I've matured, that collaboration has become more intriguing and interesting. It has taught me to let go.

press. There's a lot of other influences: there's the urban experience, the art world, the fashion world, and the best cheap food in the world. You've got to pay your rent, but beyond that, it's not a big struggle to live here. New York is becoming a serious design center, at least within the United States. This is also an easy place not to fit in—and to fit in. No one is concerned what kind of designer I am. They like the work, that's enough. It's not a manufacturing hub; that's why I've gone to Europe, but that may soon change, too.

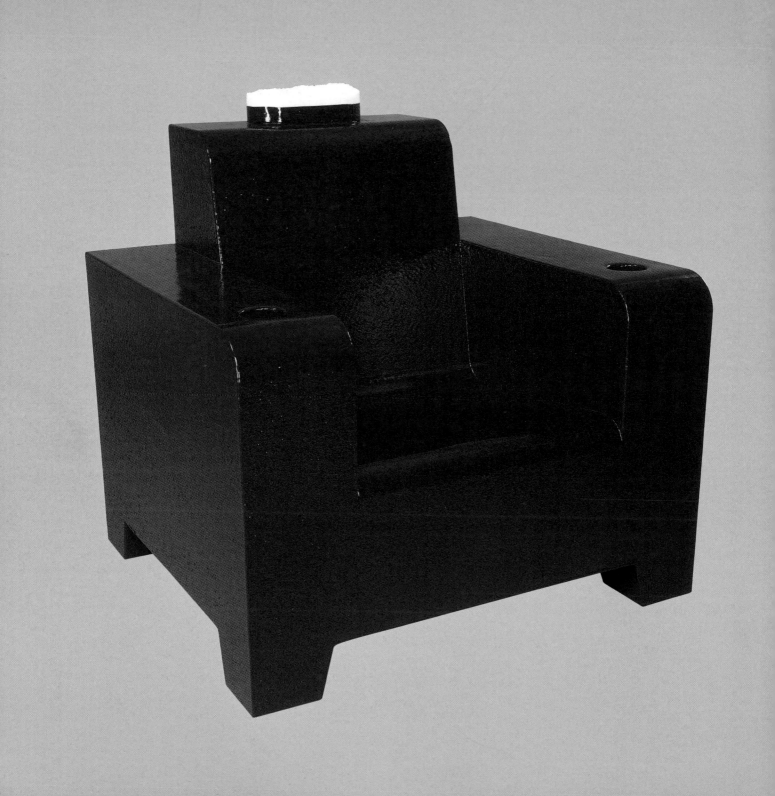

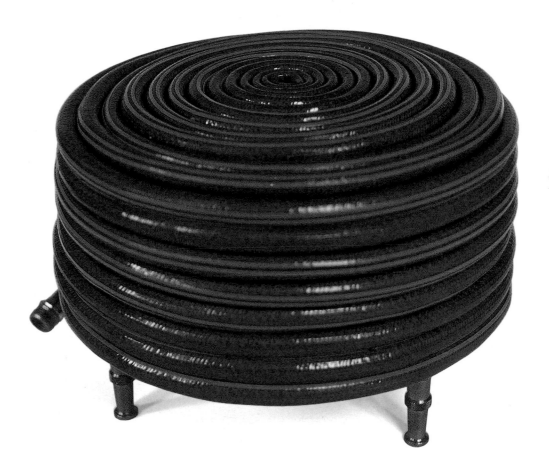

COOLER CHAIR
Eric Janssen
expanded poly-
styrene

HOSE HASSOCK
*Rodney Allen
Trice*
ready-made gar-
den hose parts

**LUGGAGE END
TABLE**

*Rodney Allen
Trice*
used suitcase,
furniture legs

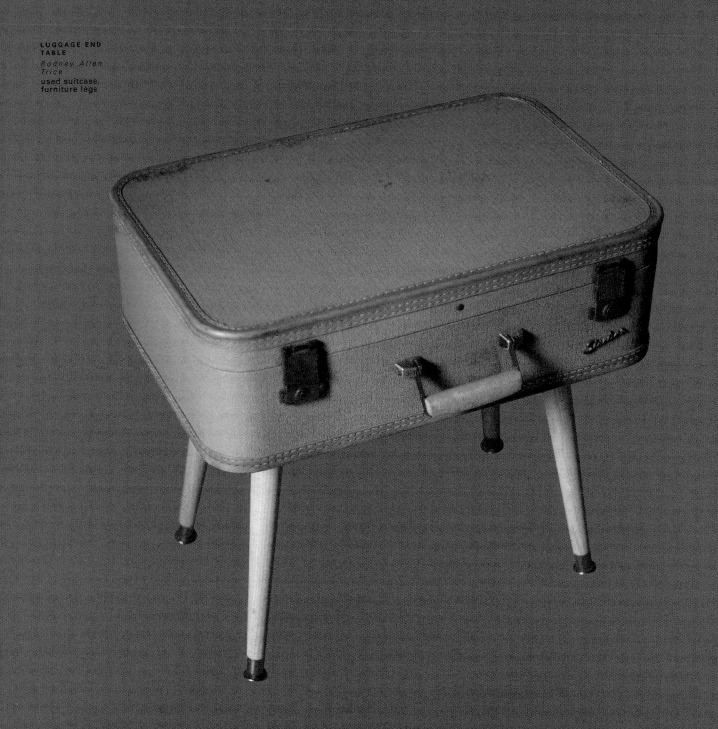

II

The Great In-Between stretches from Chicago to Boise, from Minneapolis to San Antonio. Yet for such a vast place, it seldom figures in discussions of contemporary American furniture design. During these conversations, the country suddenly shrinks into the East and West Coasts like a Steinberg cartoon. This despite the fact that it was in the Great In-Between that such modern masters as Louis Sullivan, Frank Lloyd Wright, and Mies Van der Rohe built so many of their masterworks. What greater mecca for modern skyscrapers, after all, than Chicago? What more charming modernist pilgrimage than Columbus, Indiana? Modern American furniture design has important roots here, too. It was at the Cranbrook Institute in Michigan (still one of the most prestigious design schools) that native St. Louisan Charles Eames met Ray Kaiser, Eero Saarinen, and Harry Bertoia. In the rural Michigan town of Zeeland is the headquarters of Herman Miller, a company which has been marketing modern furniture since the Thirties, when Gilbert Rohde first became its director of design.

It was in the Southwest, in Arizona, that Frank Lloyd Wright built the second of his architectural Shangri-las, Taliesen West. Today, such architectural visionaries as Will Bruder and Antoine Predock make it their base. In the early Sixties, at the University of Texas at Austin, some of the country's most influential educators in architecture, the Texas Rangers, came to the fore. In recent years, Houston's Rice University has become a hothouse for avant-garde architectural theory and design.

If modern design has flourished in this region, however, it has been in small cultural oases, separated from one another by staggeringly vast deserts of indifference and traditionalism. The Great In-Between's modernist legacy has been ignored, for instance, by Grand Rapids, Michigan, one of the country's leading centers for furniture manufacturing. Save for a few companies like Steelcase, most refuse to even consider design an essential element in product development. But this kind of attitude hasn't deterred a handful of talented contemporary furniture designers from settling here.

Interestingly, more than half came from somewhere else. Two of the three principals of the Minneapolis-based Blu Dot hail from the East Coast, as does lamp designer Emily McLennan, also based in Minneapolis. All four sing the place's praises, with special appreciation for the generosity and cooperativeness of their suppliers. This region's manufacturing resources are in fact an enormous attraction. Glendon Good of Abraxas, a native of Southern California, began designing aluminum furniture in the Bay Area before relocating his business to Sedona, Arizona, lured not only by its sumptuous scenery but also by the many metal fabricators

and welding shops in nearby Phoenix. Virginia-born David Guthrie returned to Houston to complete his architecture degree after a stint working for the avant-garde architecture firm Morphosis in Los Angeles. He stayed on to establish his solo architecture practice, captivated by the city's restless, tropical placelessness—the ideal urban condition for his brand of architecture—its plethora of industrial fabricators necessary for his furniture work, and its cheap space essential to pursuing dual architecture and furniture careers.

Being at a remove from the hype and overdrive of the great coastal cities is another boon to these designers. They savor the isolation and anonymity the region offers. It gives them the space to stretch their minds. And stretch them they do. Far from being derivative of the design on the coasts, this work is surprisingly fresh, with a clean, modern edge. The chaise longues from Abraxas and Wadsworth Design are some of the most fluid distillations of the form; Guthrie's glass-and-steel coffee tables possess all the structural clarity of a curtain wall; McLennan's wood lamps are studies in seductive abstraction.

Like so many things midwestern, this is direct and practical work. There's little fancy problem solving, but there is a lot of hands-on fabrication and attention to detail. Instead of sketching out his designs, Minnesota-bred Tom Oliphant lets them evolve out of the process of making, which is why he likes to fashion his furnishings as much by his own hands as possible. In his 7,000-square-foot shop in Detroit, Alexander Porbe of Incite Design works with a team crafting metal furniture and architectural elements that are as

These designers savor the isolation and anonymity the region offers.

finely detailed as jewelry. A background in sculpture and vintage-car restoration has given graphic designer Mark Wadsworth and his brother Paul, a gunsmith by training, the know-how to create exquisitely spare chairs and tables from Finnish birch and aluminum. While he may work with different shops on the production of his furniture line, when it comes to new prototypes or custom work, Good likes to labor over the pieces himself. The need to craft things with his own hands is what prompted him to become a furniture maker in the first place, and abandon a career as a theatrical set designer.

While much of this furniture shows real intelligence, it's not showily intellectual. There are no self-conscious references to the works of others or other influences. These design pioneers—and one has to be a pioneer to practice contemporary design in such places—are resolute about experimenting with and exploring modern furniture ideas on their own.

Not that they aren't conversant with what's going on elsewhere. A number are members of the nomadic band of contemporary designers who travel around the country to various furniture fairs, marketing their wares and services. These trips seem to provide whatever creative nourishment they need from the larger design community. Here, too, they find many of their customers. While some real furniture talent may be germinating in the Great In-Between, the region is largely barren of contemporary-design customers.

The economics of making limited-edition furnishings, especially in this part of the country, means that for most of these designers, furniture has to be a secondary pursuit to other design or architecture careers.

Mark and Paul Wadsworth have a graphic and environmental design business to support them; Porbe makes architectural sculpture and environmental elements for commercial interiors. For Guthrie, Russell Banks, and Jeff Bone of Knothead, designing custom furnishings has become a seamless facet to their interior architecture work. The three have ventured individually into small-scale manufacturing, but so far they lack the time, funding, or marketing expertise necessary to take their work to the next level of production. Good and McLennan are exceptional in having turned their custom and small-batch manufacturing into flourishing enterprises.

Making contemporary furniture design into a successful business is such a challenge that it makes Blu Dot a truly extraordinary story. The company's principals—John Christakos, Charles Lazor, Maurice Blanks—have been friends since their artsy student days at Williams College. Soon after graduation, while traveling in Asia, they began talking about starting a furniture company when they realized there wasn't any contemporary design in the market they could afford. Although they went on with their own individual pursuits—Lazor and Blanks becoming architects, Christakos obtaining an MBA and beginning a career in business—they actively incubated their idea. By fax and on weekend charettes, they conceived a furniture line from the inside out, letting the goal of inexpensive production drive the design.

Simple and stylish, with an aura of midcentury modern, the furnishings were an instant hit when they debuted in 1997 at New York's International Contemporary Furniture Fair. The infant company immediately began receiving orders, an almost unheard-of event at that particular show. Today, Blu Dot is sold not just in stores throughout the country, but in Europe and Japan. And the company is making furniture for the house brands of Crate & Barrel, Target, and Hold Everything,

bringing if not cutting-edge, then at least progressive design to mass-market retailers. With the financial security of these high-volume lines, the principals intend to experiment more with their own Blu Dot label, seeing how innovative they can be at a reasonable price and for a mass market.

Shrewd as their original concept was, and brilliantly orchestrated, Christakos is the first to admit it wouldn't have been possible without good credit and some MBA know-how, which few furniture designers have. But what makes this company so critically important is that, in three short years, it has debunked three widely held notions about American contemporary furniture: first, that there's no mass market for it; second, that nothing interesting is happening in the Midwest; and third, that it won't sell overseas. With the inventive, can-do spirit that characterized the work of the Eameses, Blu Dot has resurrected the values of the Good Design movement and its popular potential. In the quiet void of the Great In-Between, these three designers, modest, thoughtful, and wonderfully daring, have made design history. It's anyone's guess where they will go from here, and whether the region's other designers will eventually develop the means and the desire to follow.

**GRASSHOPPER
SCREEN**

*Russell Norton
Buchanan*
dacron, oak,
maple

Far from being derivative, this work is surprisingly

fresh, with a clean, modern edge.

Rationalism does not preclude **sensuality**

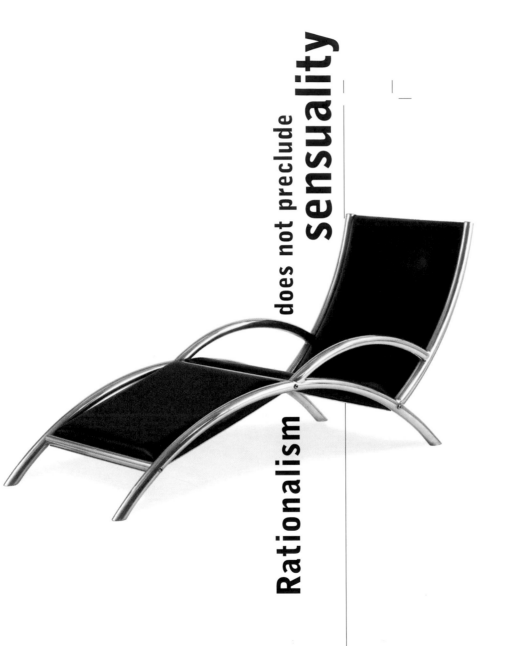

ARGUS CHAISE
LOUNGE
Glendon Good
brushed alu-
minum, leather

LOUNGE
Mark Wadsworth
birch, anodized
aluminum

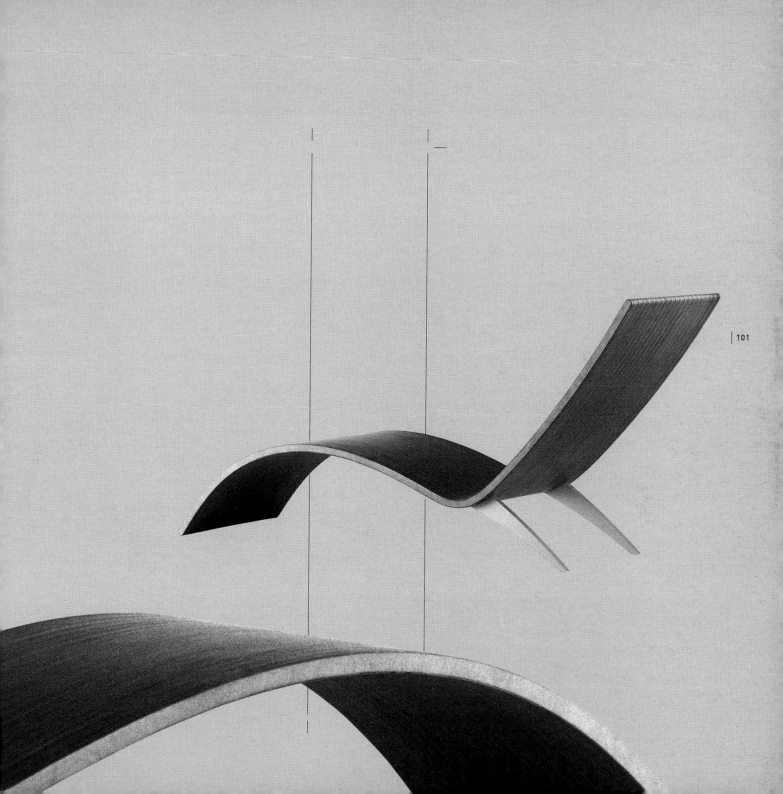

Minimalism at its most expressive. An assemblage of straight rods

**POSEIDON
SCREEN**
Glendon Good
brushed alu-
minum

_{provides} **the illusion of a forming curve.**

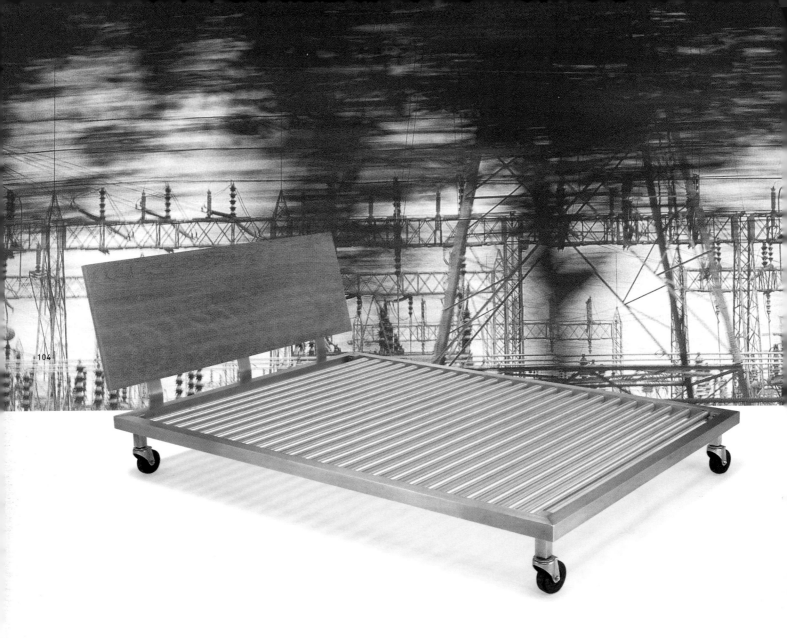

104

ATRAXIA BED
Glendon Good
brushed alu-
minum, birch
plywood

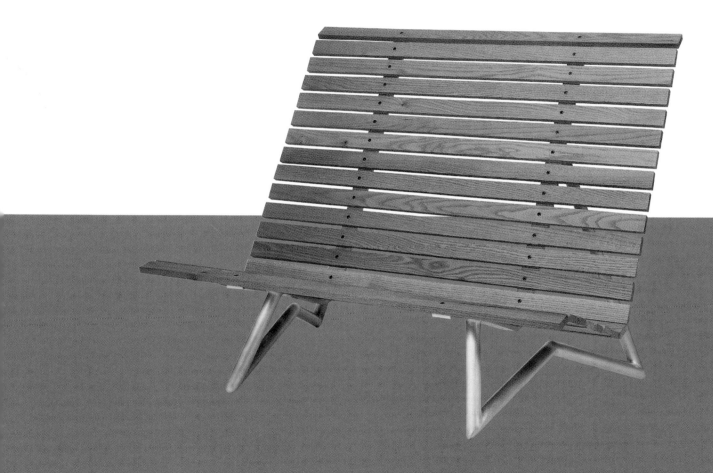

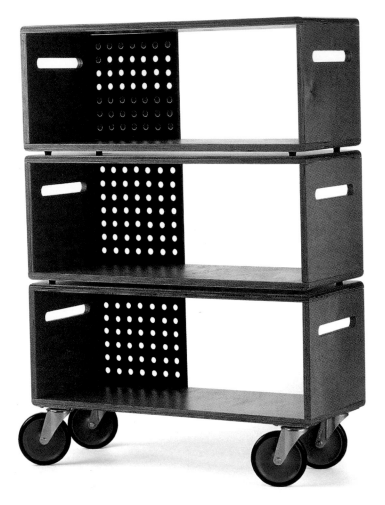

STACKABLE
GO CART
Blu Dot
birch plywood,
perforated
hardboard

"Unfortunately, it seems that design and architecture
are almost always tilted toward the highly privileged.
I honor the Eameses, who thought about how design could fit
into the idea of democracy, equality, and
service for all.
—CHARLES LAZOR, BLU DOT

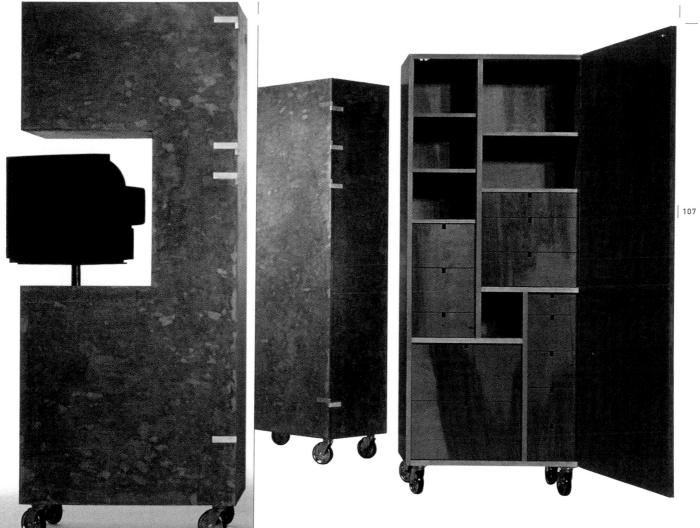

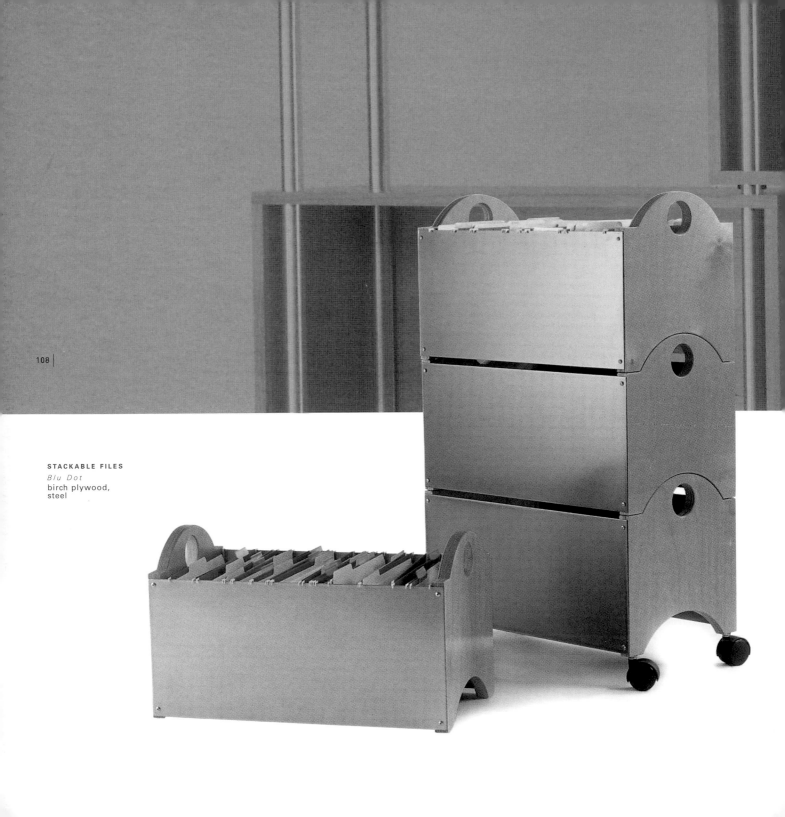

STACKABLE FILES
Blu Dot
birch plywood,
steel

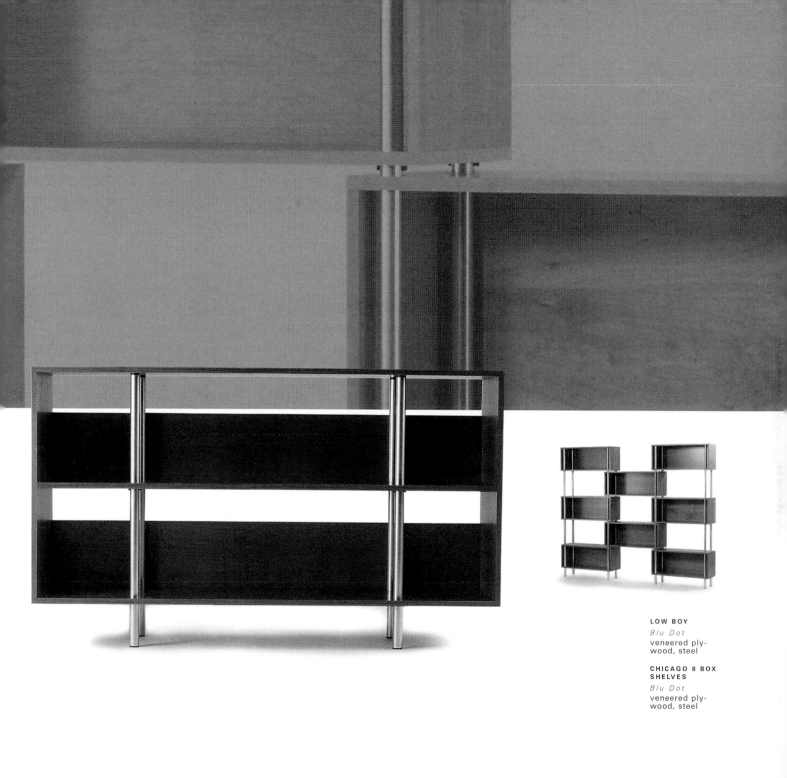

LOW BOY
Blu Dot
veneered ply-
wood, steel

**CHICAGO 8 BOX
SHELVES**
Blu Dot
veneered ply-
wood, steel

We'd always talked about designing furniture. Ever since college, we'd been designing and making furniture for ourselves. We were too cheap to buy anything and didn't like what we found. Even after we graduated and went our separate ways, with me into business, and Charlie and Maurice into architecture, the idea of designing affordable furniture still seemed a dream job. So for a while we had this make-believe company, and over the phone and by fax we'd discuss what the company would be, what it would be called, and what we would make. Once a month, we'd get together as a group for a weekend and design things. It was my job to figure out how we were going to get the stuff made. After nine months or so, we had a collection of about fifteen pieces, and we decided to go to the ICFF. This was 1997. We weren't really ready, but we didn't want to wait another year.

The reception was better than we ever could have imagined. The price threw a lot of people. Retailers were clawing for something that they could sell at a reasonable price. Our collection isn't cheap by any means, but it is affordable. We didn't expect to write any orders, we didn't even have order forms. Then the *New York Times* came by and we were one of four companies in the roundup article they wrote. We were

john christakos—blu dot

totally on top of the world. I remember looking at Charlie and saying jokingly, "So how quickly can you quit your job and move to Minneapolis?" (He actually moved to Minneapolis just a few weeks later.) We didn't have anything produced, and here we were writing orders, saying we'd ship it in six weeks. Luckily, UPS went on strike right around then. So we could hide behind the strike for about four weeks, because people were calling in asking for their orders.

What makes our furniture different—and affordable—is that we approach design from the inside out, with production, packaging, and shipping in mind. We don't just sit down and dream up our favorite coffee table. We know what kinds of machines are going to be needed for manufacture, how it's going to lay out on a piece of plywood. Efficiency is built in from the very beginning. We never designed like that when we were designing for ourselves. That's been an education. In fact, that's what makes things fun and challenging. It's pretty easy to design a cool coffee table, but it's pretty hard to conceive a cool coffee table that can be built for $188, and shipped flat by UPS. When you

put those other constraints on it, things get to be a lot more interesting.

It's evident in our work that we all share a liking of the greats from midcentury modernism: Marcel Breuer, George Nelson, Charles and Ray Eames, Alvar Aalto. We also like similar art, like Donald Judd, Carl André, Joseph Beuys, Marcel Duchamp. Donald Judd probably influences our sense of form the most. But the look of our things is driven by production. When we subject our designs to all these different filters, the stuff that comes out the other end is genuinely a by-product of what's left over. There are definitely aesthetic considerations; a lot of it, though, is driven by other things—efficiency of production, how things will pack in a box.

Our suppliers usually don't work on furniture. We co-opted technologies and processes that are used for other industrial purposes. Our biggest woodworking supplier makes store fixtures, and the only furniture they make is our parts. Essentially we're not really making furniture, we're making parts: pieces of wood that can be put together. There are no dovetail joints,

What made our furniture different is that we approached design from the inside out, with production, packaging, and shipping in mind. Efficiency is built in from the very beginning.

there's no fine craftsmanship involved. Our wood finishing is done with a company that makes prefinished hardwood flooring. Our metal is powder-coated by people who finish tractor parts for Caterpillar. When we go to some of these people, they think we're nuts. Then we come back with all these orders, and they're amazed. They're all industrial processes.

We've gone to some odd trade shows for companies that just make industrial parts and things. That stuff inspires us. For example, we're working on a little collection for Target—we don't know if they're going to take it—that's based around fiberglass lunch trays. We contacted the company that makes those, and it turns out they manufacture all these crazy fiberglass bins in interesting shapes, and we want to use them in a line of tables. In that situation, we're using off-the-shelf components that we're modifying. We don't do that often, but it's kind of fun, more playful. We get excited by things like that.

**MODULICOUS
CASEGOODS**
Blu Dot
veneered
plywood,
painted steel

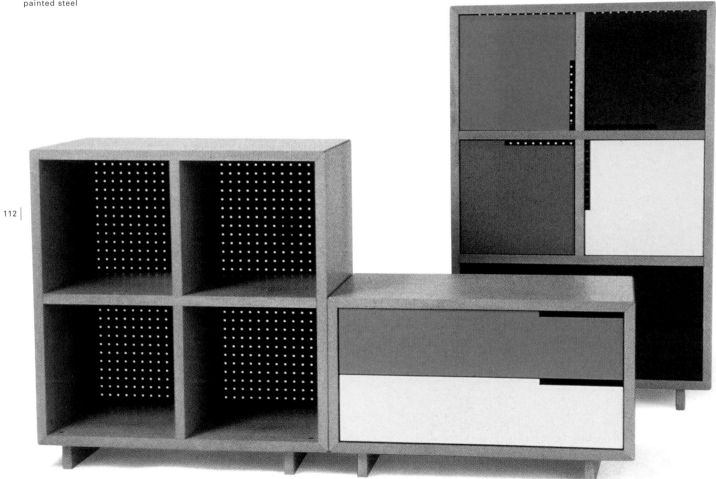

Todd Mathews
mahogany,
maple, cherry,
chromed steel

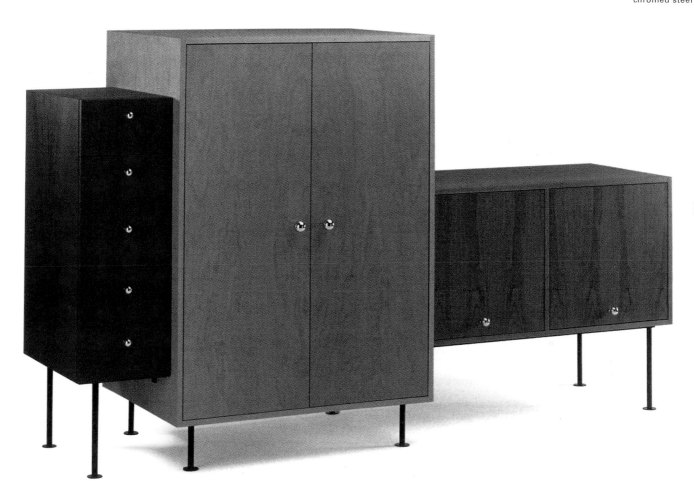

GEOMETRIC
LOW TABLE
*Stephan
Nevasil*
maple,
lacquered
wood

ARC MIRROR
Todd Mathews
veneered bent
plywood

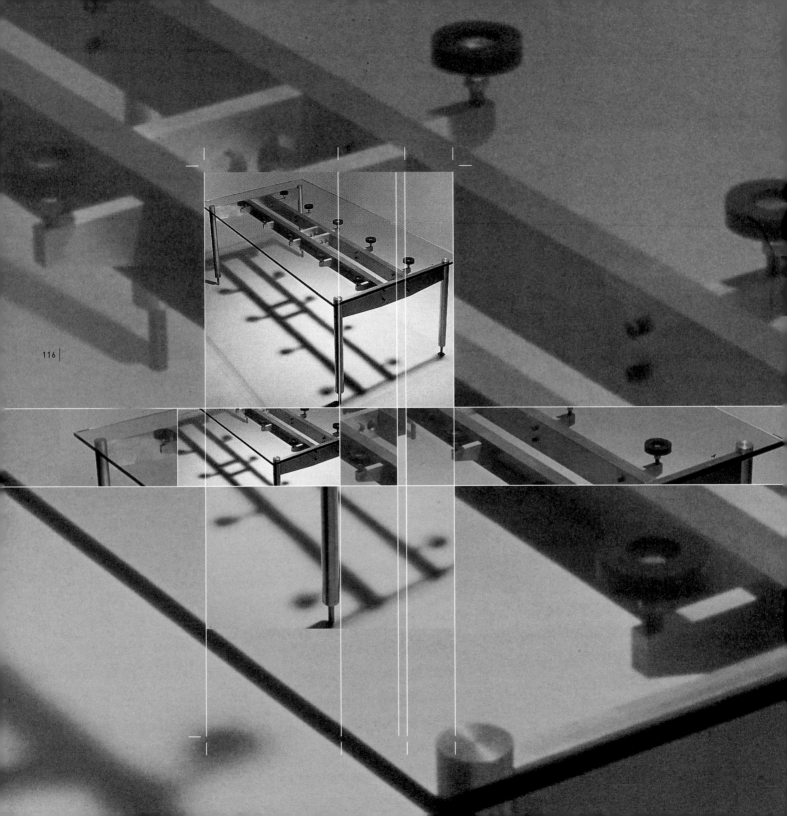

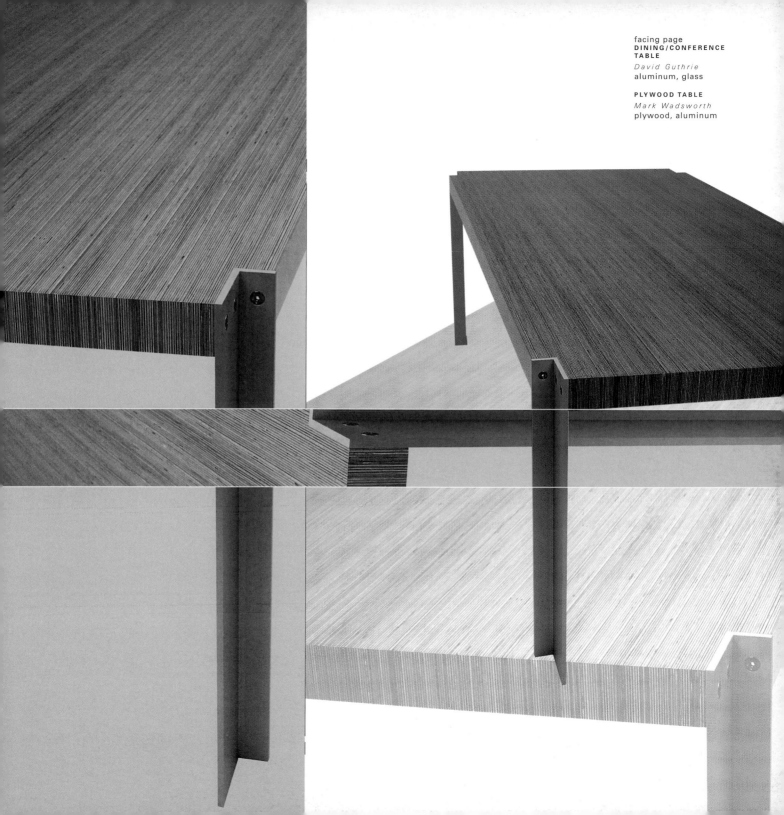

plastic shapes itself
to the designer's imagination

Previous pages
SATELLITE CHAIR
Daniel Streng
fiberglass, carbon
fiber, polyester
resin

**YAOZER
PLANTERS**
Daniel Streng
terra cotta

S-3 END TABLE
*Sean Scott for
Niedermaier*
lucite, stainless
steel

This page
CHAIR-4
David Guthrie
baby oak chair,
aluminum, perfo-
rated steel

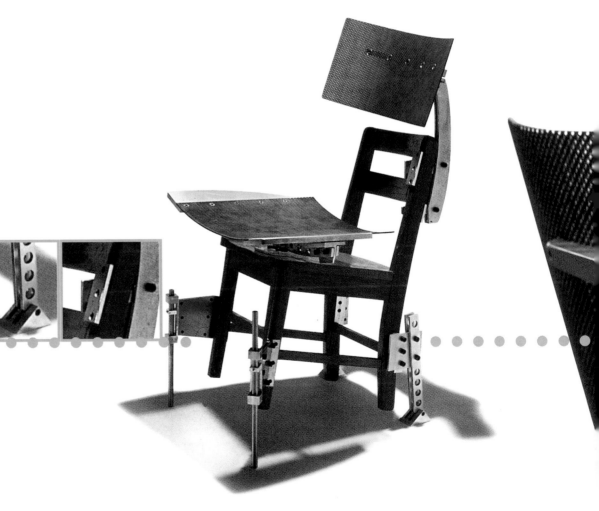

metal furnishings are crafted
to be as finely detailed as jewelry.

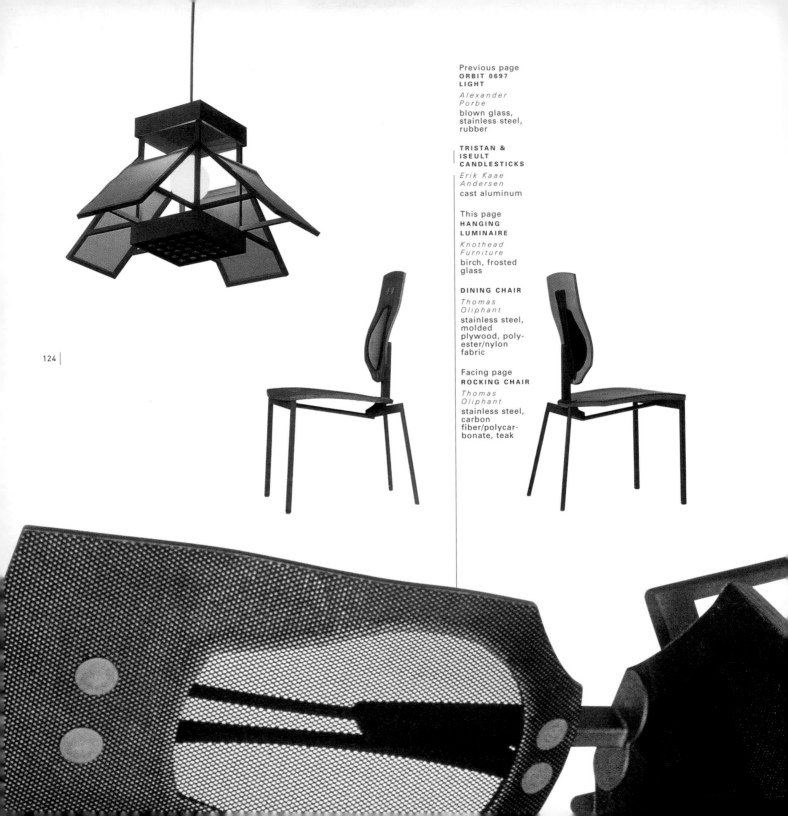

Previous page
**ORBIT 0697
LIGHT**
*Alexander
Porbe*
blown glass,
stainless steel,
rubber

**TRISTAN &
ISEULT
CANDLESTICKS**
*Erik Kaae
Andersen*
cast aluminum

This page
**HANGING
LUMINAIRE**
*Knothead
Furniture*
birch, frosted
glass

DINING CHAIR
*Thomas
Oliphant*
stainless steel,
molded
plywood, poly-
ester/nylon
fabric

Facing page
ROCKING CHAIR
*Thomas
Oliphant*
stainless steel,
carbon
fiber/polycar-
bonate, teak

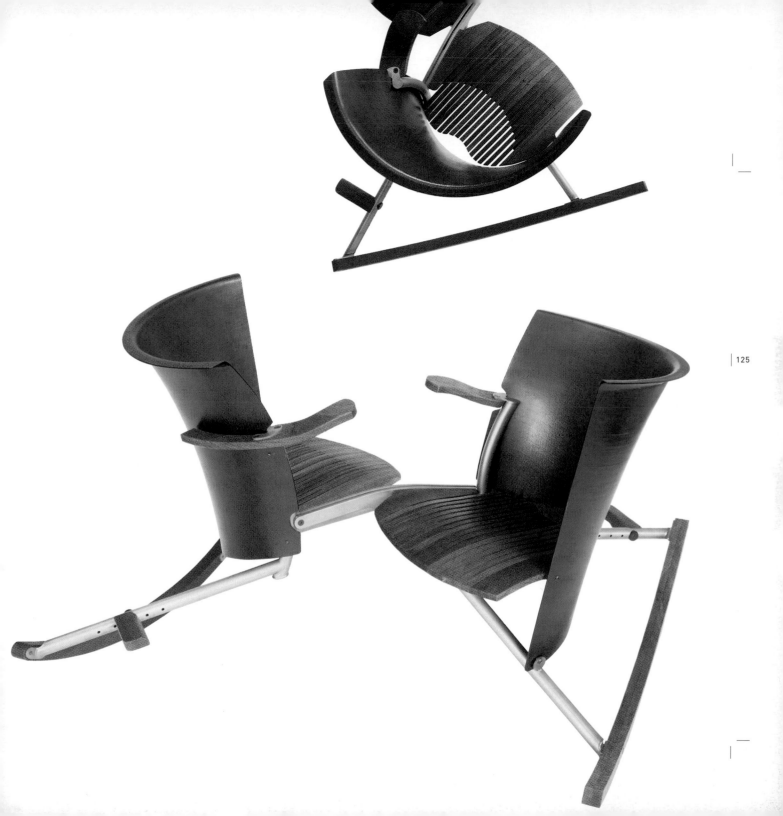

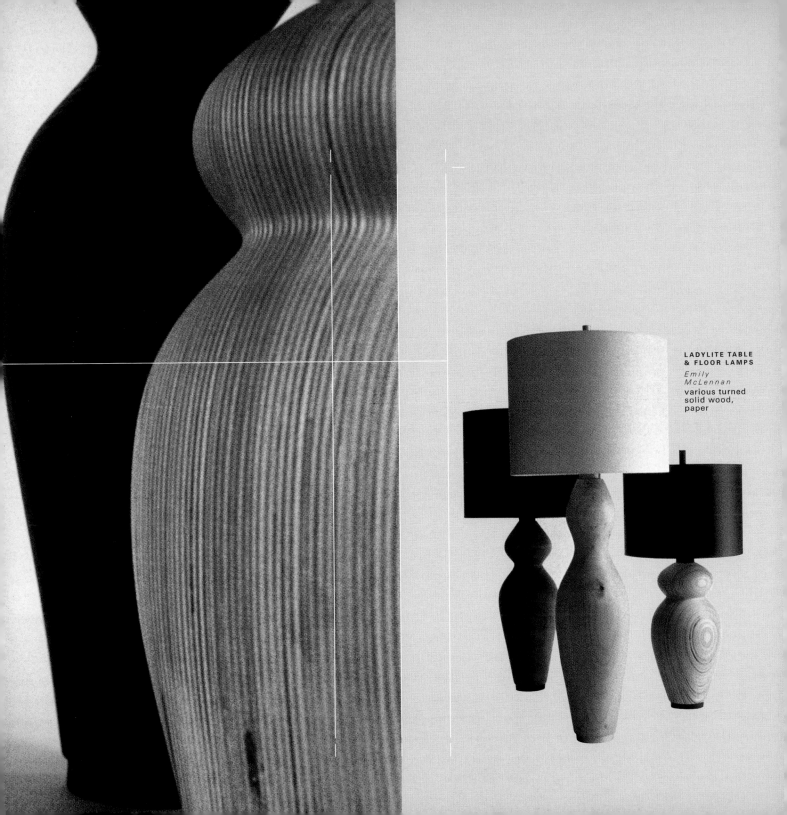

**LADYLITE TABLE
& FLOOR LAMPS**

*Emily
McLennan*
various turned
solid wood,
paper

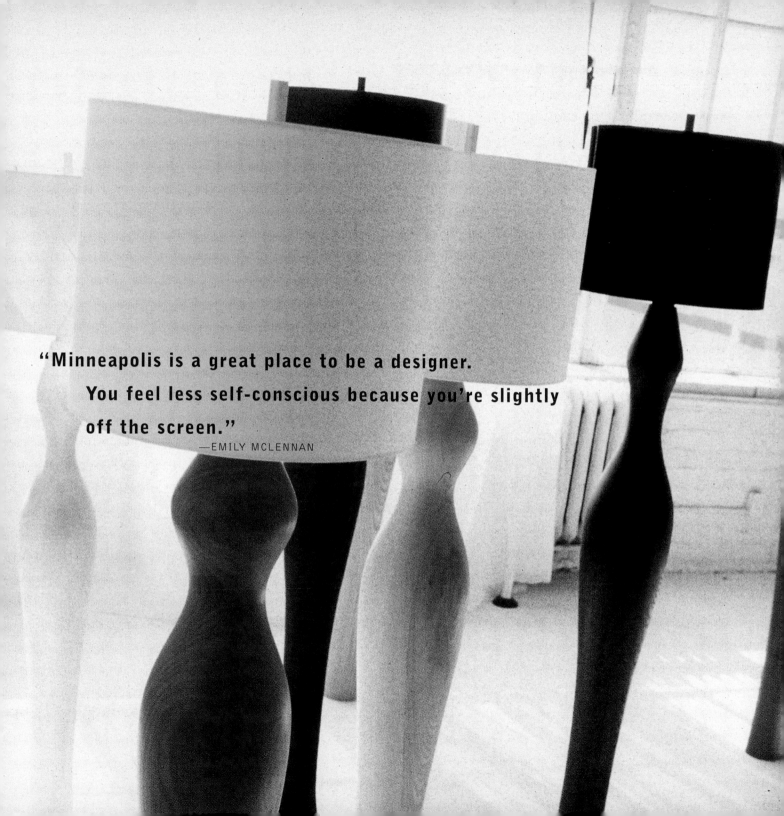

"Minneapolis is a great place to be a designer.
You feel less self-conscious because you're slightly
off the screen."
—EMILY MCLENNAN

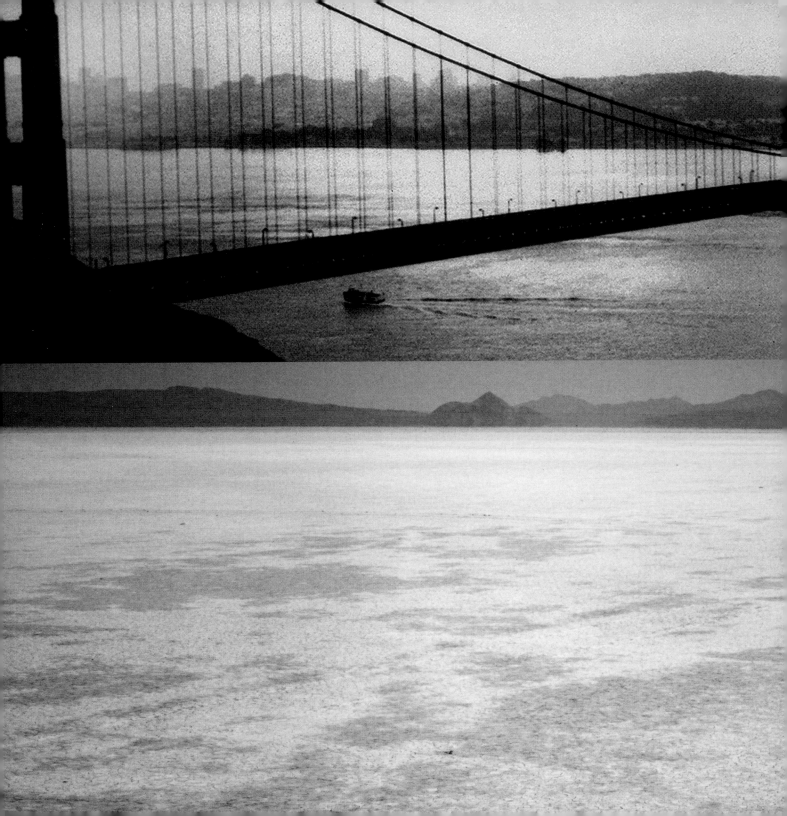

III

the WEST

Barstow
Los Angeles

the west

The American West is emblematic of many things—the unexplored frontier, the edge, the fringe, the Promised Land, a place of endless gold, sun, and possibility. No matter how mythical, the image of the West has been alluring enough to attract a continuous stream of settlers, eager to discover what they could harvest or build on this virgin ground. Those who make the trek out West are innately territorial; call it a matter of geographic selection. They are claim-stakers by character, unafraid of heading toward the unknown horizon in pursuit of a better life.

To be territorial is to assert a relationship between ourselves and our place. We invest these bonds with great meaning, for they fortify our sense of who we are. So strong is this territorial urge that it extends beyond place to things. This owes, perhaps, to the fact that one can go no farther upon reaching the continental edge, "the natural conclusion of America's manifest," as one historian put it. With the land settled, pioneering Westerners continue to seek territory to explore or create, from the illusory celluloid world to outer space, from our invisible inner depths to the sprawling cyber-universe. Hollywood, Lockheed, Esalen, and Microsoft alike have changed our perception and experience of the world, expanding its boundaries to encompass our imagination, other galaxies, our spirits and senses, and our worldwide webbed connection with each other.

The urge to make rather than theorize is characteristic of this creative outpost. There is a hands-on quality about the furniture, conveying an esteem for the human touch and spirit. These are subtle acts of territorialization in which objects gain meaning from their ties to their maker and user. The Arts and Crafts movement thrived in the West, unsurprisingly. From Southern California to the San Francisco Bay Area to the Pacific Northwest, its adherents valued the imprint of the maker, challenging the onslaught of soulless, artless goods produced by factories in a fast-modernizing, alienating world. Though the movement took various forms throughout the industrialized world, its manifestation in the United States was not aimed at the banishment of the machine but at the intelligent use of it. It was California's most celebrated designers, Charles and Ray Eames, who perfected the application of mass-production logic to domestic furniture, but their work reflected a similar desire: to humanize an increasingly mechanized world.

In this humanist vein, much of this furniture eschews the intellectual, ironic, and art references characteristic of designs coming out of other major urban poles, like New York or London, instead responding strongly—and simply—to people's needs and contexts.

The work is not heady, but it is pleasurable; it's not intellectual, but social—a contribution to "the good life," which has been the banner for Western living since people began settling here. Influential magazines like *Arts and Architecture* in Los Angeles (which began as *Pacific Builder*) and *Sunset* in Redwood City saw California living as a model for improved modern life everywhere. Even the L.A.-based *Architectural Digest*, with its glossy displays of all manner of styles, from ranch to baroque (anything, as long as it's *riche*), has, like the Eameses, done much in exposing design to a mass audience.

If a significant amount of the furniture currently being designed on the West Coast has a distinctly Eamesian air, it's because these designers are striving to realize the best of what West Coast living can be. Curiously, though, the legacy of the Eameses is now stronger in Northern, rather than Southern California, as the latter's aesthetic has become increasingly theatrical.

West Coast design is about not simply finding new things to make or new ways of making them, but finding new ways of living. Responding to the spectacular landscape, openness of space, and benign climate, California designers, north and south, pioneered lifestyles that banished old formalities and boundaries, introducing a casualness that manifested itself in open-plan houses and garden terraces that extended the house's borders into the outdoors. Richard Neutra, Rudolph Schindler, and the many Case Study architects in Southern California, and William Wurster, Joseph Esherick, landscape architects Thomas Church and Garrett Eckbo, and even mass-house-producer

Lifestyles today demand undemanding furniture.

Joseph Eichler in the north set the stage for furniture that no longer needed an image and function that corresponded to specific places in the home. A chair was a chair was a chair—as long as it was well designed. Sturdy construction and weather-resistant material meant it could be used outside. Informal furniture found its best audience in California.

It's worth noting that the Pacific Northwest, too, shares the same predilection for informality. Like California, it has demonstrated a strong tradition of regional response. Its designers have also found it difficult to ignore the extraordinary natural landscape, and have embraced a way of life and making things that incorporates nature and all its serene pleasures.

In the the 1990s, this sense of casualness, informality, and ambiguity grew even more ubiquitous as the boundaries between life and work, home and office became ever more blurry. Miniaturized, portable technology (born in the Silicon Valley) has allowed us to be mobile and remote, to disengage from place. Much of L.A.'s business is conducted in cars. Offices in the Silicon Valley are modeled on college campuses. Homes everywhere have offices. People work at home, in cafés, or live at the office. Though this phenomenon is increasingly global, the West as the quintessential culture of self-invention and bastion of casualness is leading the revolution.

As a result, a tendency toward simplicity, openness, and utter practicality dominates this work. Neutral in image, stripped to essentials, pieces can thus slide easily from one context to another. This intention is well served by the material vocabulary of the midcentury

moderns: light, molded plywood and slender steel, for example, impart a clean, familiar look while also being easily handled by designers. The use of this vocabulary by Bay Area and Pacific Northwest designers gives their work a retro air. CCD's Block Storage System, Union Furniture's component-based Proun Desk, Park Furniture's bookcases, Tom Ghirladucci's folding tables, and Bravo 20's Lounge and End Table all look as if they could be from the classic period of modern American furniture.

While designers in the Bay Area, Portland, and Seattle are closer in sensibilities, aspiring to more subdued, classic forms, those based in Southern California are more cheeky, more gestural in their designs. The works of Lush Life and In-House, for example, are large pronouncements, whimsical statements. For all the values that West Coast design shares, Los Angeles's creative impulses are decidedly different from its northern neighbors. There is a premium on "events," dramatic moments that punctuate life in the sprawling auto-formed landscape. This was the breeding ground for the Googie roadside vernacular, which found architectural outlandishness the best marketing device in a publicity-crazed environment.

More recently, the so-called L.A. School of Architecture is distinct for its explosive forms that punctuate the otherwise repetitive blandness of this broad-boulevarded city. By contrast, there are no Frank Gehrys or Eric Owen Mosses or Thom Maynes in the Bay Area and Pacific Northwest, where architecture blends in more than stands out, respectful of the intrinsic beauty of the terrain and views. L.A. style is about grabbing attention, corresponding to a more ostentatious, appearance-driven lifestyle. But that doesn't mean the furniture is without substance: most of the work embodies a sense of fun, and playfulness was one of the key ingredients to the Eameses humanist approach.

Furniture design in the West is deceptively simple. In responding to our increasingly complex lives, it is more intelligent than it appears. Keeping things simple is complicated. The West, long a leader in lifestyle revolutions, continues to cue the world into what the future of good living may be.

the bay area

One of the earliest, most successful manufacturers in San Francisco was Levi Strauss & Co. The company prospered by supplying nineteenth-century gold-digging miners with durable denim attire. Now an emblem of functionality and casualness (and the epitome of Americanness), Levi's offer a sort of shorthand for the Californian lifestyle: life should have a "relaxed fit," like a favorite pair of jeans, with a comfortable feel and look that enables you to move from one part of your life to another, seamlessly. In the Bay Area, which first advanced the notion of the casual workplace, every day is jeans day. Underlying this ethos is the idea that if the different aspects of one's life are so disconnected as to require different wardrobes, then something must be amiss.

If the furniture in this book can be said to reflect a dominant aesthetic, it would be a West Coast brand of "simple chic": straightforward, open, unadorned. The furniture of Bravo 20, CCD, Pablo Pardo, Park Furniture, and Goods! can be seen as the small-batch equivalents of Smith & Hawken, The Gap, and Banana Republic—West Coast companies which have made their mark with a pared down, almost generic style. Unsurprisingly, many of the designers in this section count The Gap and Banana Republic as their

clients, providing them with interior design services, custom fixtures, or commissioned products.

Gary McNatton, design director for products for both companies, in fact was once an independent designer— a colleague of many of the furniture makers in this section. His company, Mottura, and its line of spare cubes of transparent soaps and fragrances in simple brushed-aluminum flasks were absorbed into The Gap's line when McNatton was hired to direct the clothing giant's personal care products. He now brings in the work of small producers to sell under both companies' names; for example, Pablo Pardo's lights and waste-baskets are also sold elsewhere, but in the Banana Republic houseware department fall under the house label. If the work does not appear terribly original or groundbreaking, it's due in part to its success: The aesthetic of these young designers have in the past five years gotten absorbed into the mainstream.

What remains innovative, however, is their responsiveness to changing lifestyles. How designers and users think about furniture, their perceptions and expectations, has changed significantly. In the Bay Area especially, people increasingly resist set notions of living, preferring the blurry in-between space where work and play, house and office, indoor and outdoor overlap. Lifestyles today demand undemanding furniture. There's no longer the space or desire for furniture that is bulky or unwieldy, difficult to move or requiring upkeep. In image and use, flexibility is the ultimate value.

To accommodate fast and fluid lifestyles, West Coast designers are producing furniture that offers basic,

There's a preponderance of furniture that is multifunctional, collapsible, portable, movable, and flexible in terms of function and aesthetics.

stylish versatility—furniture that can be lived with on a long-term, noncommittal basis. The simpler the work, the more adaptable it is to different uses and contexts. This explains the preponderance of furniture that is multifunctional, collapsible, portable, movable, and flexible in terms of both function and aesthetics. The Scissor Table by John Randolph, for instance, snaps into two positions, able to function as both a dining and coffee table. Remove the sausage-shaped back cushions of Bravo 20's lounge and it becomes a bed. The top of Canan Tolon's Telephone Table flips up, turning into a seat—in case a phone conversation goes on longer than expected.

Daven Joy of Park Furniture designed his straightforward shelf system after moving every year for the last five years. Frustrated with packing and unpacking boxes, his system is a spare welded case in which box-shelves—and their contents—may be moved in and out discretely. Sigmar Willnauer's Zip-Table and Zip-Light for Goods! have minimal components, are collapsible and portable, packed into flat portfolios. Countless other West Coast designers are producing works that are modular and wheeled.

If furnishings are to be widely adaptable, they need to be simple in concept. Standardized parts show up often, for both economical and idealogical reasons: the beauty of the ready-made owes much to its accessibility. The work is above all "user-friendly," a term that originated with the Macintosh computer, conceived by the fabled local industrial-design firm frogdesign. This icon of tamed technology, like so much Bay Area furniture, owes its charm to its accessibility.

The casual workplace and the reconfigured structure of work (flextime, compressed workweeks, telecommuting) are geared to the ultimate modern lifestyle ideal—expanding leisure time, or at least, a better integration of one's pleasures into daily life. Many of the designers in this book, like many Bay Area residents, take their outdoor avocations as seriously as they do their work. In fact, quite a few have been creatively influenced by the region's numerous outdoor-gear companies. Before establishing his now locally well-known custom-furniture workshop, South Park Fabricators, Jeff Sands made parts for skateboards and mountain bikes. Recently, he founded another company, Switch, which manufactures quick-release bindings for snowboards. Brian Kane's Rubber Chair for Metropolitan cleverly appropriates a bicycle's foam handlebar grips for its frame. Willnauer's Zip products were inspired by the simplicity and collapsibility of a North Face tent. Bravo 20's Eric Pfeiffer admired the work of an East Bay skateboard manufacturer, which is now making components for him. Says Pfeiffer, who, like many of his young colleagues, surfs every morning, "If you're looking into the ocean every day, you can't help but see your life and work in a different way."

At the basis of this work is a certain sensuousness, a desire to feed the senses. Simplicity doesn't have to be severe. These furnishings have a deeply human feel, owing to the hands-on nature of their production. Most of these designers "fabricate" their furniture, placing it somewhere between cottage craft and factory-style manufacturing. Yet it is almost always designed with mass production in mind, thus possessing the logic and image of industrial design. South Park Fabricators' Universal Café chair, for example, is composed of sand-cast aluminum and formed plywood parts, yet on close inspection it's clear that these pieces have spent time in a jig and were assembled by hand. "You could say that we have the crafts-

man mentality in that we often designed on the shop floor," notes Larissa Sand of South Park Fabricators. "Although volume production is a goal, we want to keep an aspect of production in-house because it allows us to develop ideas and know the materials better."

By and large, these designers operate from modest-sized shops, designing, fabricating, and assembling parts; packaging, promoting, and distributing their products all from in-house. They produce work in limited batches, with parts tooled in-house by hand or contracted out locally to ample vendors who mill, mold, weld, and cast whatever's needed. The existence of a rich network of artisans and industrial shops owes itself in part to the strong legacy of the Arts and Crafts movement on the West Coast. Like their predecessors, these designer—makers espouse principles such as truth to materials, honesty of construction, concern for quality, utility, economy, and beauty in everyday objects. One of the Bay Area's most famous design figures is Bernard Maybeck, a bohemian turn-of-the-century architect, who dreamed of creating a design/craft collective where woodworkers, metalsmiths, ceramists, and glassmakers would collaborate and offer a sort of one-stop service shop to architects and homebuilders. While singular in their craftiness, his houses in Berkeley offered a distinctly modern counterpoint to the ornate Victorians raging at the time, with their open floor plans, their engagement of the site, their total design approach.

In its early days, South Park Fabricators did short-run production work for a collection of local companies: hangers for Esprit, store fixtures for The Gap, interiors

134

for North Face. In addition to marketing their own products, the sophisticated metal shops of Goldin Design and Alan Sklansky execute large and small specialty commissions. Park Furniture and Bravo 20 also balance their own design and production with custom commissions either based on their own designs or to the specifications of the client.

Many participate in SF Portfolio, a loose assembly of more than twenty small makers that share ideas, resources, and marketing materials. A spin-off group, USDA represents IOOA, CCD, Bravo 20, and Park Furniture. Both groups have made strong showings at furniture fairs like New York's ICFF. These designers and fabricators feel like they are a real community—one that in some manner continues the Bay Area's old utopian ideals. The Eameses, too, had a messy workshop style which they believed generated more possibilities.

Because they are so hands-on, the principals of these companies tend to gravitate toward materials and technology that are familiar, available, basic, and deliberately low-tech. The use of wood, metal, glass, concrete, and production methods like die-cutting, molding, welding, and casting minimize complexity, and ensure the freedom to directly manipulate (i.e., territorialize) materials however they please. Such known materials and techniques can also be made fresh by recontextualizing, though. Take, for example, Willnauer's Zip products, which bring sewing into the realm of rigid furniture by applying zippers to leather and birch plywood.

One of the reasons these designers stick to the tried and true is that exploring new materials is costly. Most of these designers, because they self-finance their manu-facturing, can't afford this form of experimentation. Studio eg, for instance, has succeeded by investigating only the lowliest of new materials. Wholly devoted to ecodesign, principals Erez Steinberg and Gia Giansullo have developed a multipurpose table out of a colorful, recycled–plastic composite top and pressboard base, and an entire modular office system with wheatboard surfaces and shelves, recycled-cardboard cylinders as supports, and panels of compressed newsprint.

Although the Bay Area remains the epicenter for technological tremblers that bring us ever closer to the realm of virtuality, immateriality, and disembodiment, its residents demonstrate a deep desire to be connected to the real, to the material. In short, they want to be grounded. Almost as if to be reminded of their humanity, they prize life's sensual rewards. It's no coincidence that the Bay Area has been fertile ground for the clean-food revolution, the craft-baking revival, countless self-potential movements, and a plethora of new out-door sports, from snowboarding to extreme mountain biking. The new Bay Area furniture is yet another medium for providing calm, comfort, and continuity, a means of tempering the aftershocks wrought by huge leaps and quakes of faith.

PARALLEL PLAY TABLE
Michael Goldin
plywood, plastic laminate, painted steel

At the height of European modernism's influence, Le Corbusier looked to the United States and was enthralled by its industrial buildings. Grain elevators, water towers, airplane hangers and other engineering triumphs signaled to him a uniquely **American modernism**—one which embodied the reduction, economy, and clarity to which all good modernists aspired.

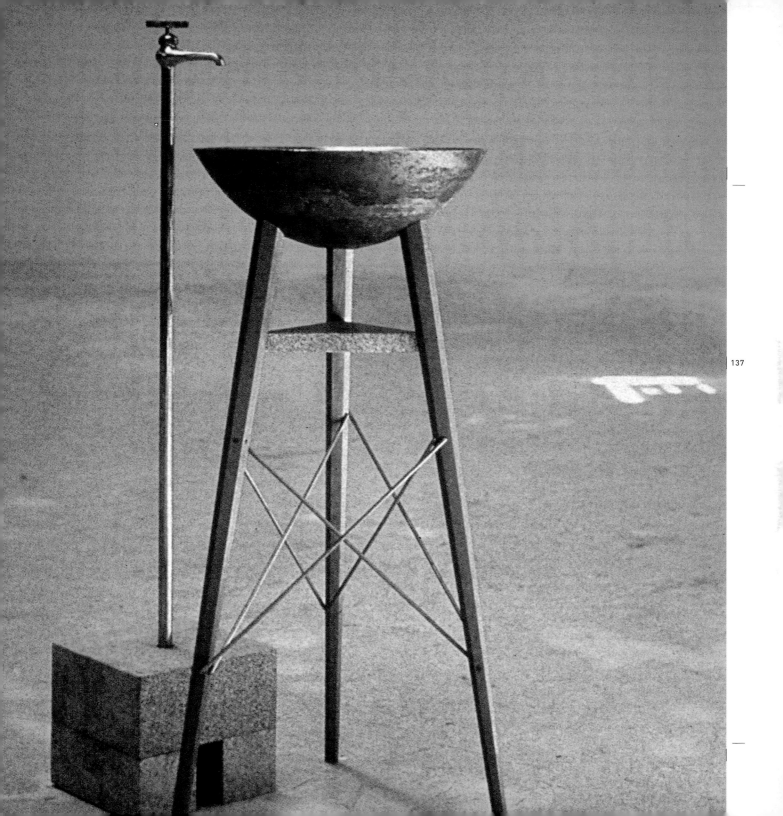

"The buzz here in the Bay Area is that it's all about processing information. I can see furniture getting more intelligent, becoming storage for information. Just because works are simple doesn't mean that they aren't intelligent."

—DAVEN JOY, PARK FURNITURE

Previous Page
WASH STAND

Bruce Tomb
cast white bronze, maple wood, stainless steel, Sierra granite

This Page
430 DRESSER

Daven Joy
stainless steel, aluminum, mahogany, neoprene

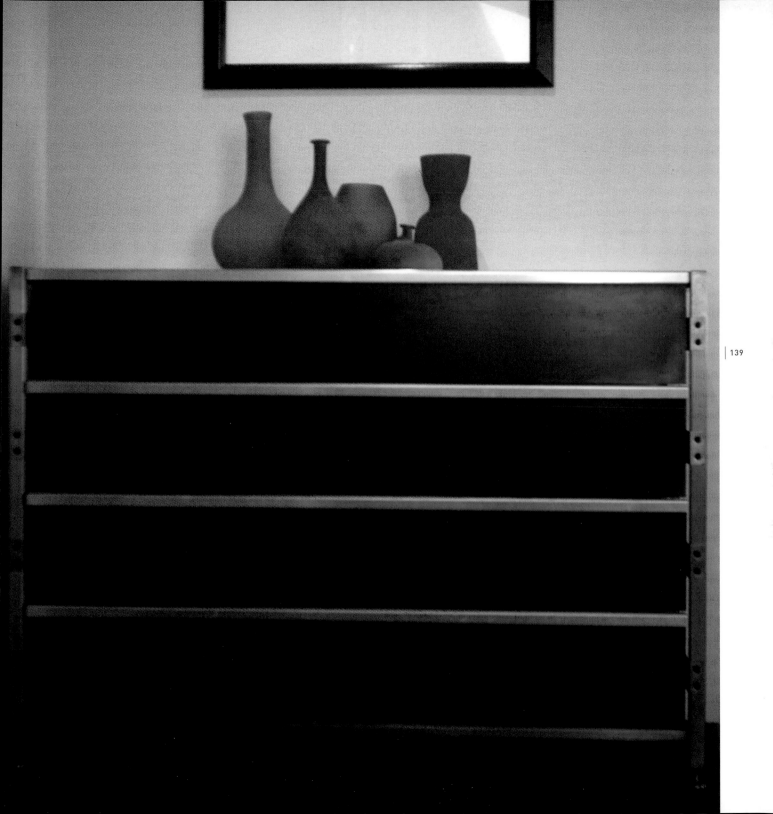

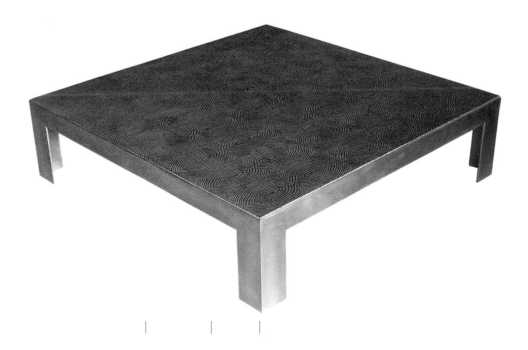

END GRAIN COFFEE TABLE
Paul Smith
aluminum frame,
Douglas fir top

Facing page
SPRING BACK CHAIR
*Union Furniture &
Fabrication*
maple

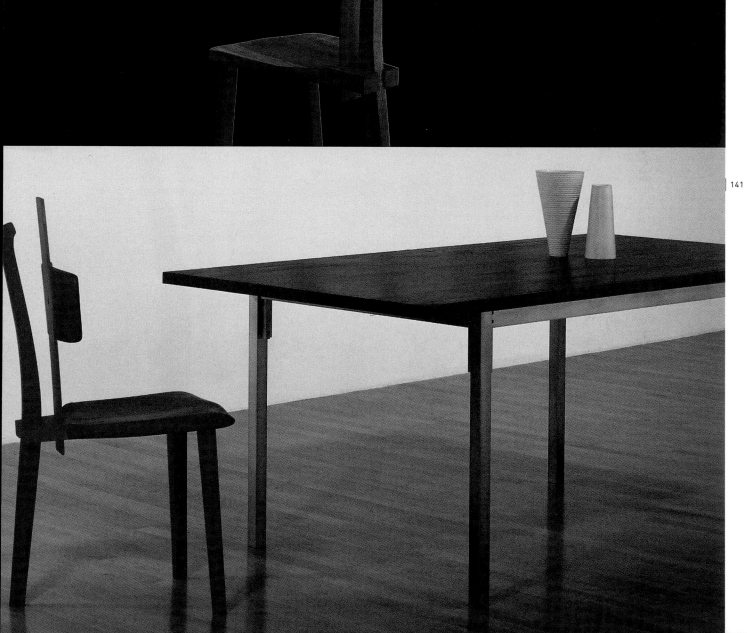

Fabrication is someplace **between the cottage "craft"** **or shed mentality, and the factory.**

CHAIR
Federico de Vera
anodized aluminum,
hand-dyed nylon
cords

COAT HANGER
Eric Pfeiffer
cast aluminum,
stainless steel

UNIVERSAL CHAIR
Jeff & Larissa Sand
cast aluminum,
formed maple
plywood

**CITY BLOCK
STORAGE SYSTEM**
*Christopher
C. Deam*
aniline-dyed
plywood, maple
plywood, aluminum

**INTERIOR WITH
1415 SHELVING**
Daven Joy

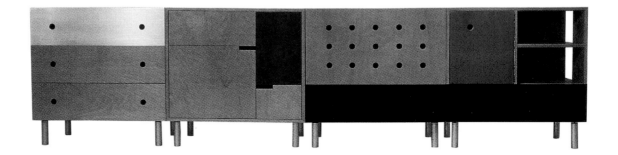

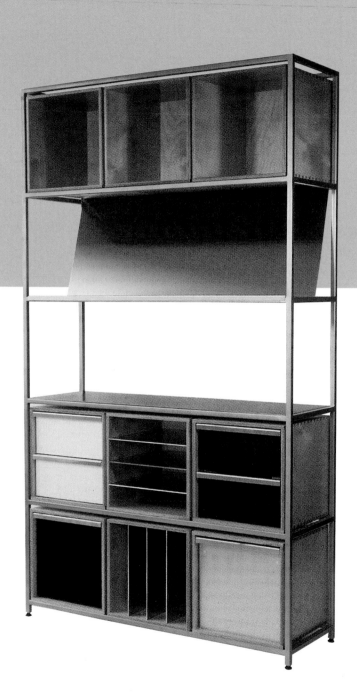
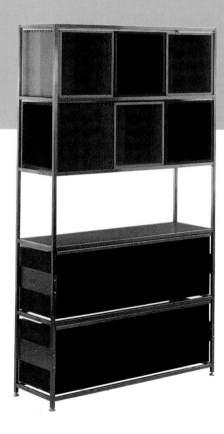

1514 BOOKCASES (CUSTOMIZED)

Daven Joy
stainless-steel frame, birch ply-wood, aluminum drawers, neoprene facing

LADDER BOXES
Walter Craven
veneered wood,
powder-coated
steel, anodized
aluminum

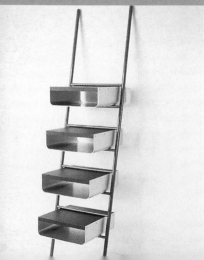

**TIER
SHELVES**

*Cristopher
C. Deam & Tim
Power*

**painted MDF or
veneered wood,
aluminum**

Respect
for materials means not simply letting them do what they want, but pushing them to do what they can.

WING VASE
Eric and Silvina Blasen
recycled polished cast-aluminum

SOFT BOX CUSHION
Tom Ghilarducci
leather

SWINGSIDE TABLE
Walter Craven
lacquered wood, stainless steel, leather

TACTIC DESK & TABLES
Charlotte Bjorlin
ash, birch, cherry, walnut, leather

**METAL STOOL
& WOOD STOOL**
David Gulassa
hand-formed
metal,
carved wood

CONE TABLE
Buddy Rhodes
precast color-
infused
concrete

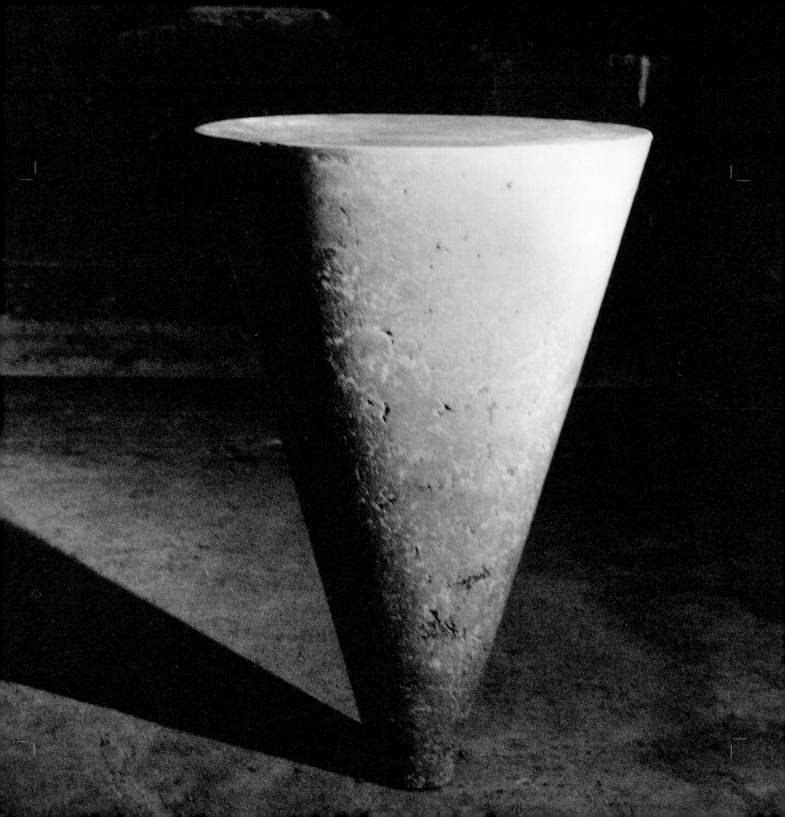

cycle

Re-

154

the way we look at materials

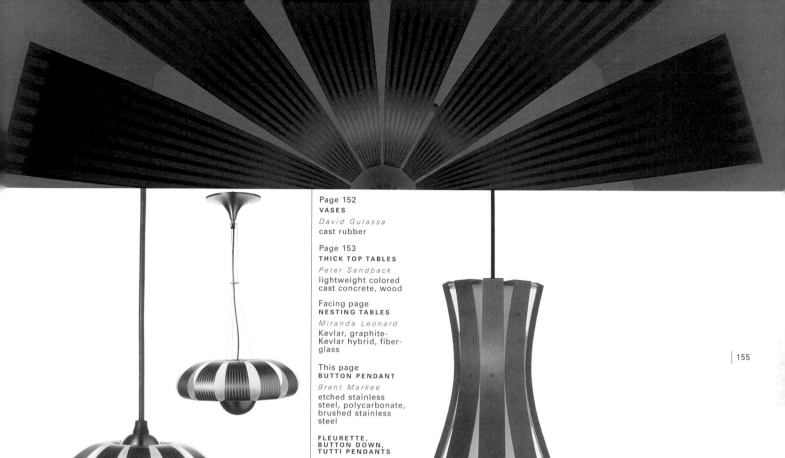

Page 152
VASES
David Gulassa
cast rubber

Page 153
THICK TOP TABLES
Peter Sandback
lightweight colored
cast concrete, wood

Facing page
NESTING TABLES
Miranda Leonard
Kevlar, graphite-
Kevlar hybrid, fiber-
glass

This page
BUTTON PENDANT
Brent Markee
etched stainless
steel, polycarbonate,
brushed stainless
steel

**FLEURETTE,
BUTTON DOWN,
TUTTI PENDANTS**
Brent Markee
etched stainless
steel, polycarbonate,
brushed stainless
steel, anodized
aluminum

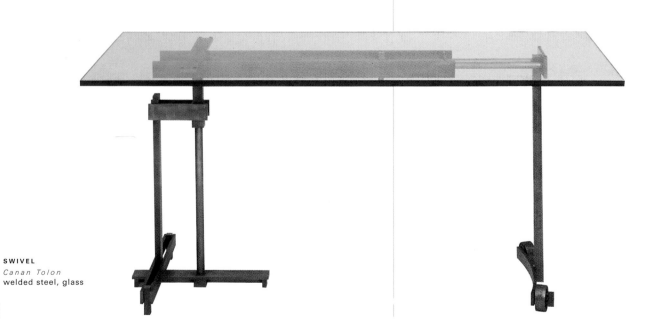

SWIVEL
Canan Tolon
welded steel, glass

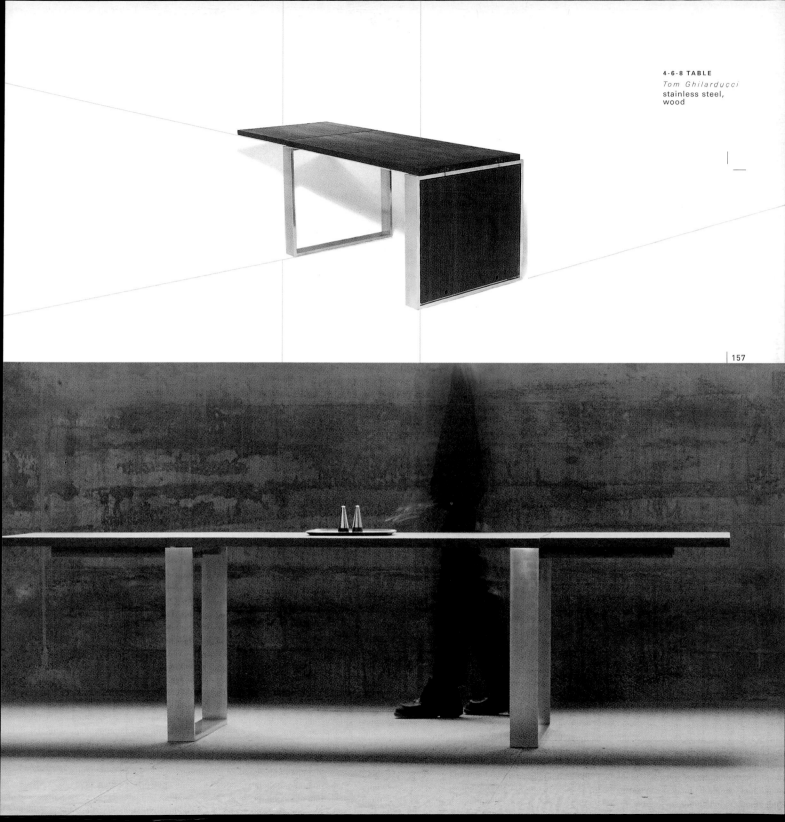

4-6-8 TABLE
Tom Ghilarducci
stainless steel,
wood

SEATABLE
Canan Tolon
cold-rolled bent
sheet metal

The simpler the work, **the more** adaptable

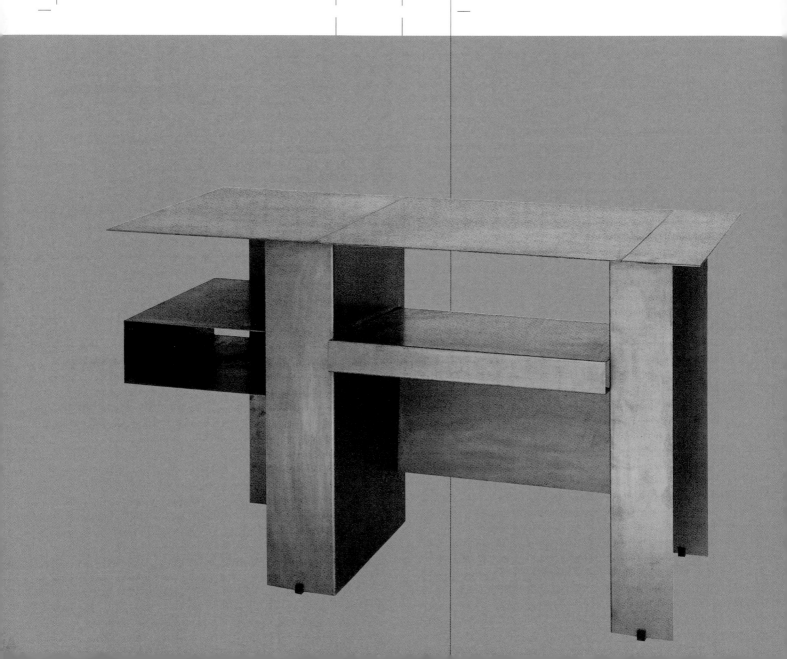

it is to different uses and contexts.

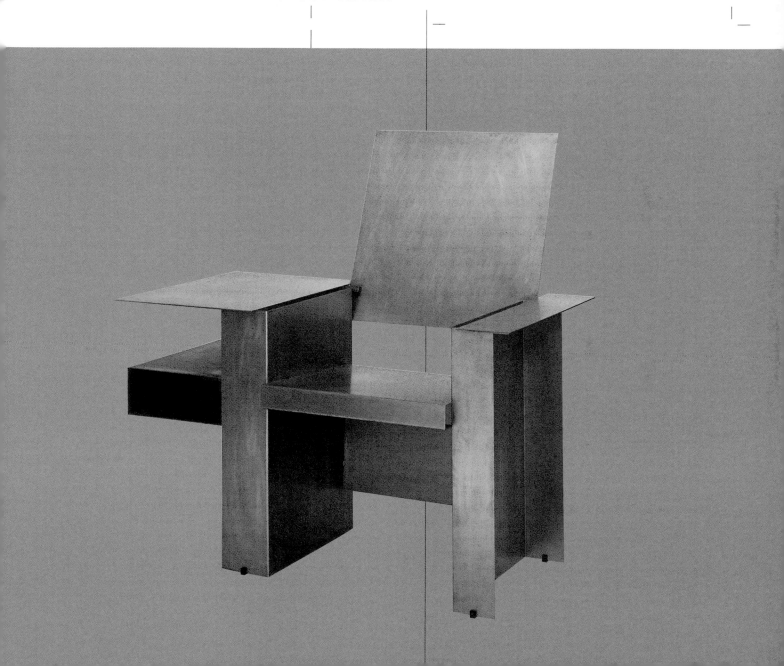

Previous page
SCISSOR TABLE
John Randolph
maple plywood,
solid maple,
steel

john randolph

Somewhere about the age of two, my parents tell me that I developed a fascination with outfitting my red metal wagon and a wheelbarrow with cardboard structures fashioned from big appliance boxes that they would give me. Some of my earliest memories come from building these mobile structures, and sitting in them to be fed by my mother, who would pass food through small slots. I never lost this taste for mobility and the desire to create place within space.

In 1983, my former collaborative partner, Bruce Tomb, and I took over an industrial space in what is now San Francisco's Internet mecca—about a thousand square feet of raw, open space that we affectionately called an "urban cave." It was there where we started experimenting with furniture out of both need and aspiration. We wanted to better understand how fixtures and furniture mandate the way place is distinguished within the bigger context of a room. The first piece of furniture we created was from a slab of granite acquired from a construction site that we set on some concrete blocks. Under this cold, hard surface we placed a small radiant heater plugged into the room's only source of electricity, an overhead light above this table. The heating of this table made that stone the source for warmth and dialogue for a

year. It was from this place that we incubated new ideas about using the design of fundamental, rudimentary furnishings to reshape and hone architectonic ideas at a scale and cost that we could control and realize. In other words, furniture would be our medium for expressing architectural ideas.

In terms of materiality, I see the West Coast as a great place to be a designer. Since the majority of the technology that develops new material seems to be here, it's like being a forty-one-year-young kid in a candy shop. So much to try with so little time. Although I guess I'd rise to the occasion if I were dropped in the desert or shipwrecked on a tropical island, where the materials were predetermined. This ability to make do with what is available is the gift that any designer must acknowledge. The materials that I gravitate toward depend on the context of the problem.

With respect to production, I see my work rapidly evolving away from a place-bound way of working. With the proliferation of computers in design and rapid advances in fabrication technology, especially here in the Bay

Area, we independent designers/fabricators on the West Coast are faced with a strange catch-22. The tools and toys that surround us to make design and production more efficient have created such a boom economy that we are being forced to move away due to the extreme cost of doing business here. Good design is a team effort between designer and fabricator. Many of the fabricators that we have developed valuable and unique working methods with are now too expensive or have simply relocated outside the region. Ways of working are becoming less dependent on face-to-face interaction and more dependent on disembodied communication. Don't get me wrong, I'm not a neo-Luddite or some machine smasher; on the contrary, we are being forced to work in a new way that is counterintuitive to the paradigm of what we have known as a species since the beginning of recorded time. We may have tools and vehicles that can make this new way of working possible, but it is astronomically expensive for the innovative sole practitioner to perform his craft in a society that thinks good design comes easy and can be obtained at the click of a mouse, at the "speed of

As designers, we look for the anomalies in the world and find great inspiration in the simple, elegant solutions in the ideas of other inventors in the past.

business," and at Ikea prices. Why can't both private and public sectors understand that design is the business of ideas, and that investing in the brain trust of American designers is good business and would only benefit the haves and the have-nots both qualitatively and quantitatively?

My fear is that the spirit of innovation will be squelched by the monoculture that has appropriated the norm. A good hardware store is next to impossible to find. Old-school methods, mechanisms, findings, and solutions are disappearing to big chain stores that provide only standard items. That is not how inventors work. We look for the anomalies in the world and find great inspiration in the simple, elegant solutions in the ideas of other inventors of the past. "Good inventors borrow, great inventors steal," to paraphrase Picasso.

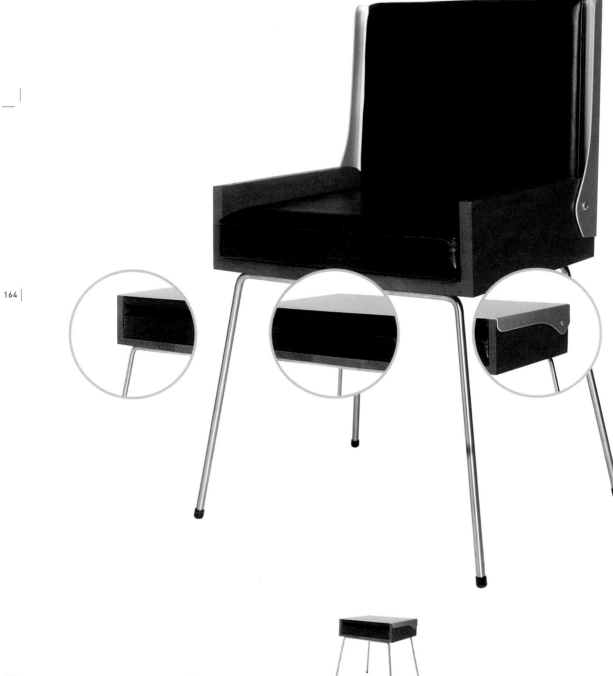

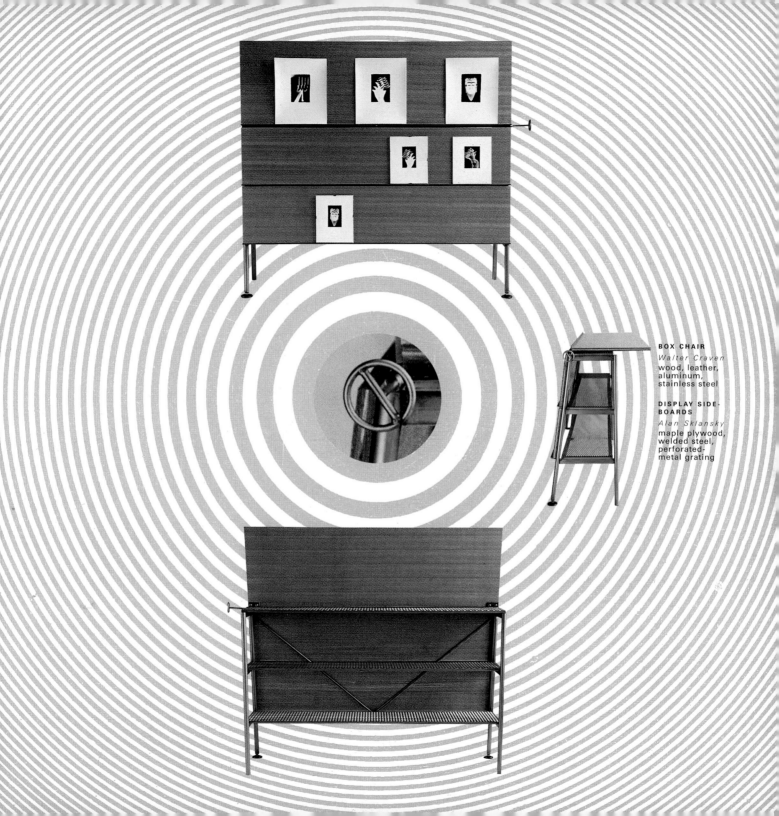

BOX CHAIR
Walter Craven
wood, leather,
aluminum,
stainless steel

**DISPLAY SIDE-
BOARDS**
Alan Sklansky
maple plywood,
welded steel,
perforated-
metal grating

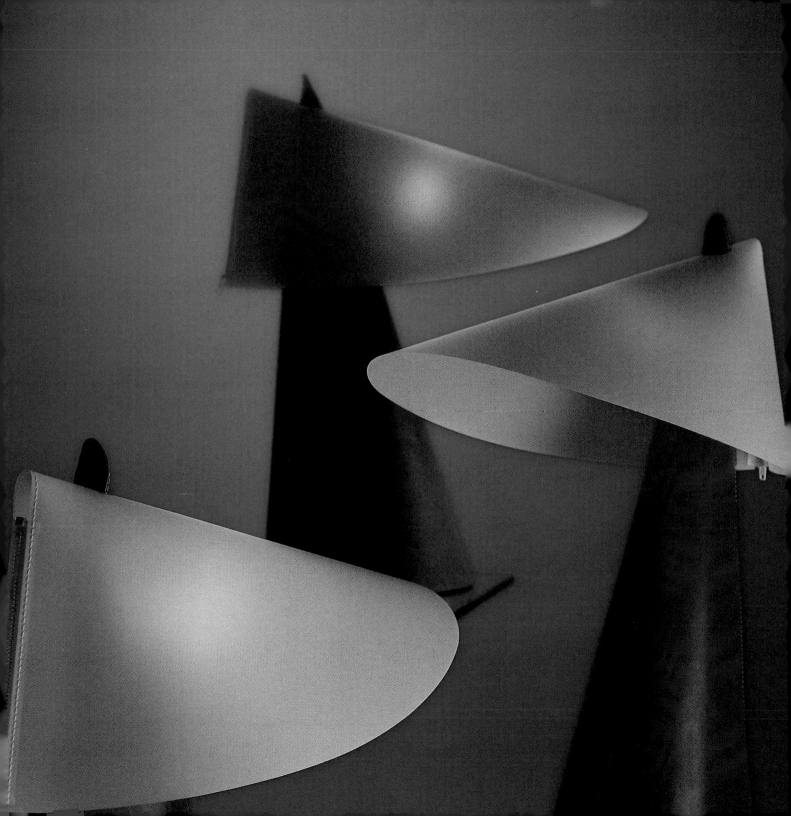

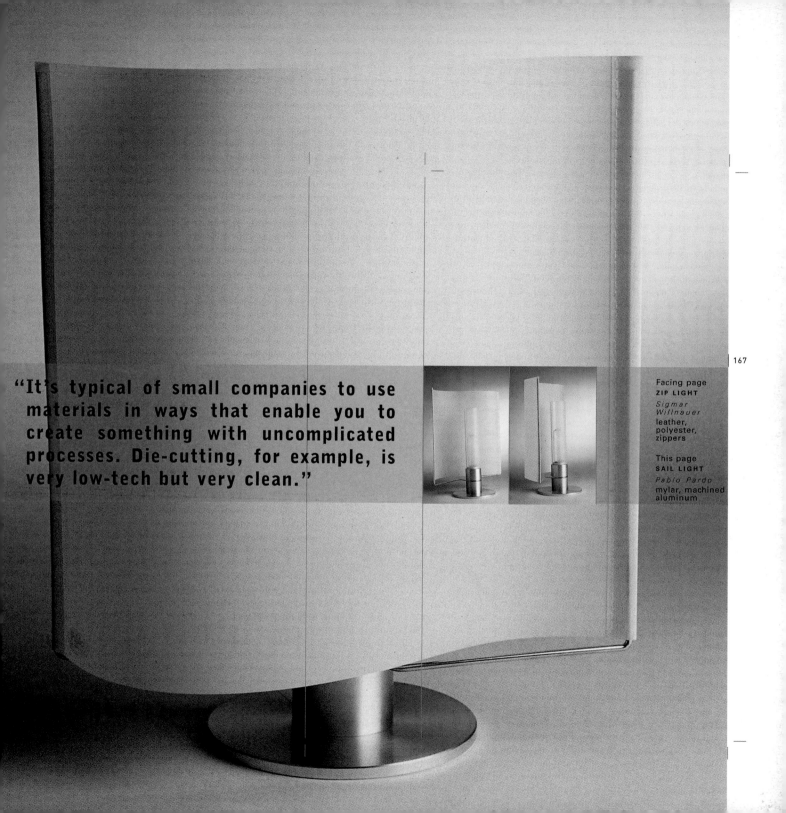

"It's typical of small companies to use materials in ways that enable you to create something with uncomplicated processes. Die-cutting, for example, is very low-tech but very clean."

Facing page
ZIP LIGHT
Sigmar Willnauer
leather, polyester, zippers

This page
SAIL LIGHT
Pablo Pardo
mylar, machined aluminum

COVEY STOOL
Jeff Covey
cast aluminum
or formed ply-
wood seat,
chromed steel

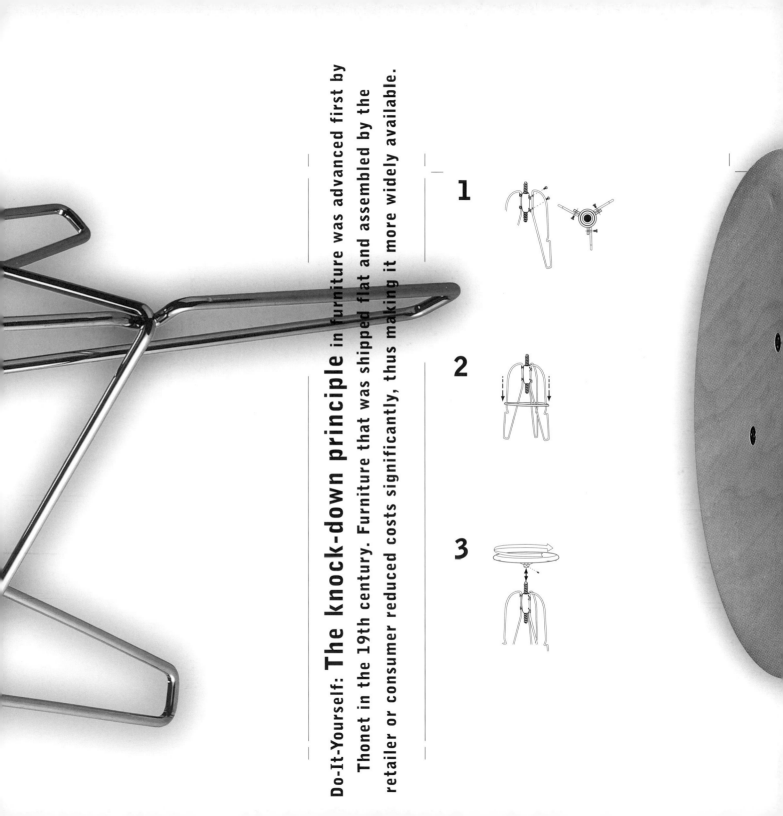

Do-It-Yourself: The knock-down principle in furniture was advanced first by Thonet in the 19th century. Furniture that was shipped flat and assembled by the retailer or consumer reduced costs significantly, thus making it more widely available.

1

2

3

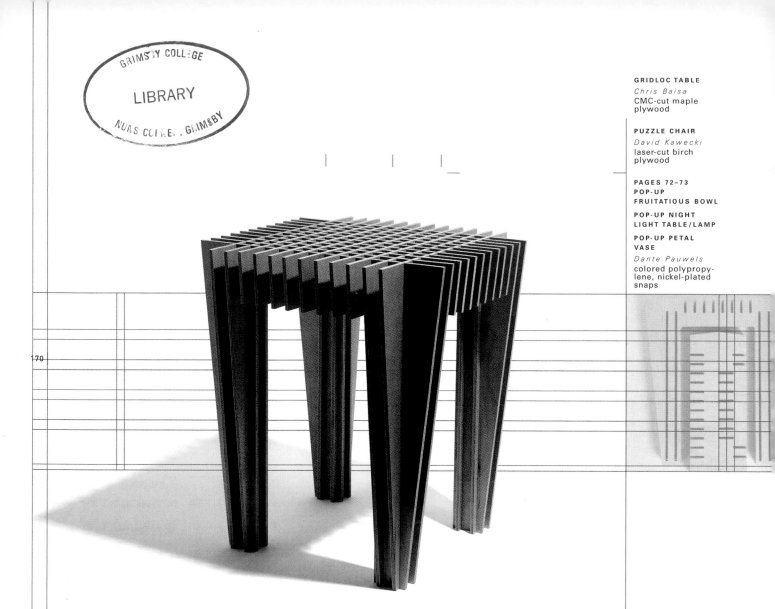

GRIDLOC TABLE
Chris Baisa
CMC-cut maple
plywood

PUZZLE CHAIR
David Kawecki
laser-cut birch
plywood

PAGES 72–73
POP-UP
FRUITATIOUS BOWL

POP-UP NIGHT
LIGHT TABLE/LAMP

POP-UP PETAL
VASE

Dante Pauwels
colored polypropy-
lene, nickel-plated
snaps

Precision-cut parts
fit together as snugly as early crafted
mortise-and-tenon joints.

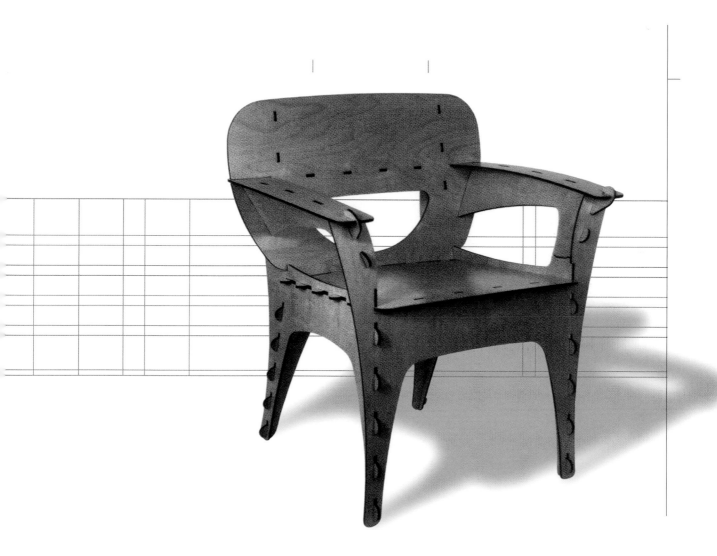

With hardware eliminated, this furniture is
self-contained like a nomad's tent.

(AF) ** OVERRUN CENTERLINE
(HIGH INTENSITY)

(V) VISUAL APPROACH SLOPE
INDICATOR

ALL LIGHTS WHITE - TOO HIGH
FAR LIGHTS RED } ON GLIDE SLOPE
NEAR LIGHTS WHITE } (2½°-3°)
ALL LIGHTS RED - TOO LOW

NOTE: DIMENSIONS GIVEN ARE
FOR STANDARD INSTALLATIONS.
SOME VARIATIONS MAY EXIST

NOTE:

RUNWAY CENTERLINE
LIGHTING (MAY BE INST-
ALLED IN CONJUNCTION
WITH ANY APPROACH
LIGHTING SYSTEM)

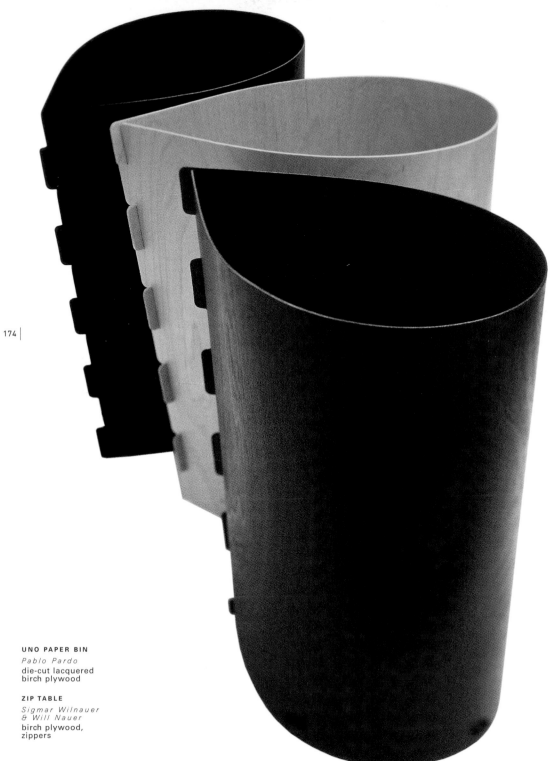

174

UNO PAPER BIN
Pablo Pardo
die-cut lacquered
birch plywood

ZIP TABLE
*Sigmar Wilnauer
& Will Nauer*
birch plywood,
zippers

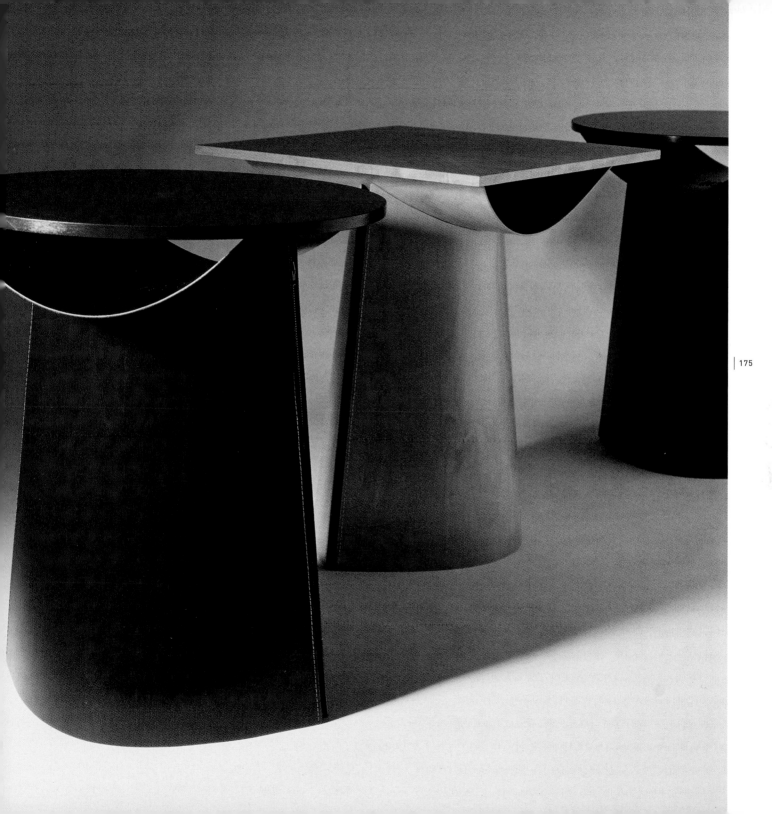

**LAUREL CHEW TOY,
STICK CHEW TOY,
CROWN CHEW TOY**
Tom Bonauro
molded vinyl

CROWN BOWL
Tom Bonauro
glazed ceramic

Facing page
LOW BONE TABLE
Eric Pfeiffer
laminated plastic,
plywood, powder-
coated steel

Objects have personalities, like their users.

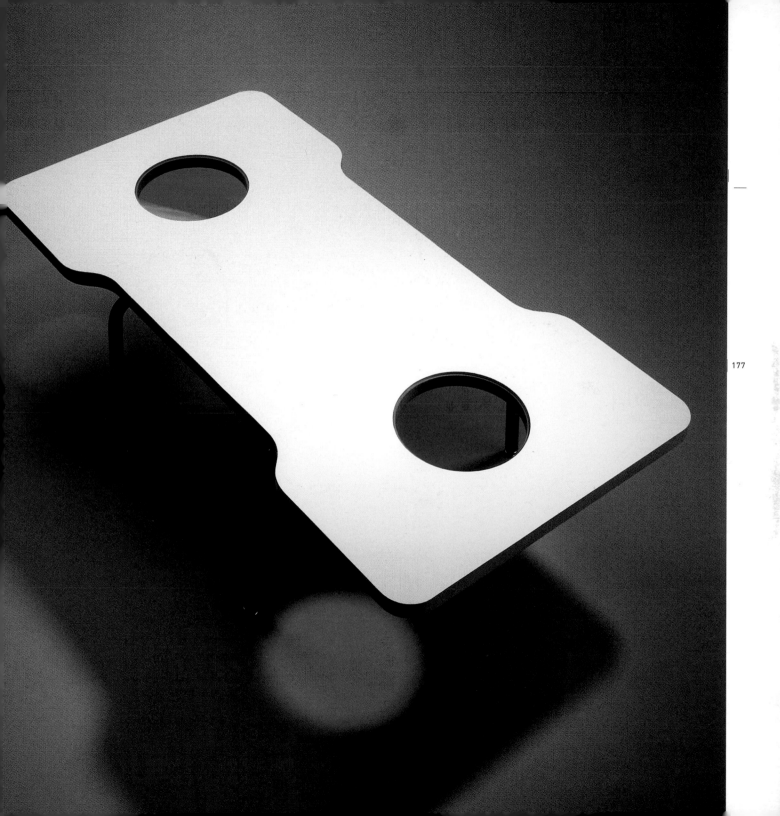

RD 2 ELEVEN SHELVES
Roz Hayes & Dani Stoller
resin-coated plywood, pow-der-coated steel

THE THING CUSHIONS
Mark Zuckerman & Monty Lawton
upholstery, steel

MR. TANAKA CHAIR
Roz Hayes & Dani Stoller
iridescent vinyl, brushed alu-minum

AFTER-HOURS LOUNGE
Roz Hayes & Dani Stoller
polyurethane, powder-coated steel

WET LAMP
Roz Hayes & Dani Stoller
powder-coated steel, ball chain

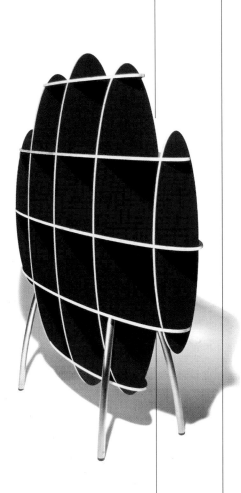

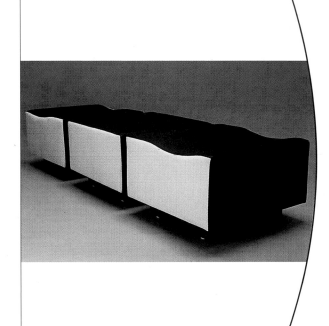

| **KNEW SWIVEL WINGBACK CHAIR**

Roy McMakin
mohair uphol-
stery, wood

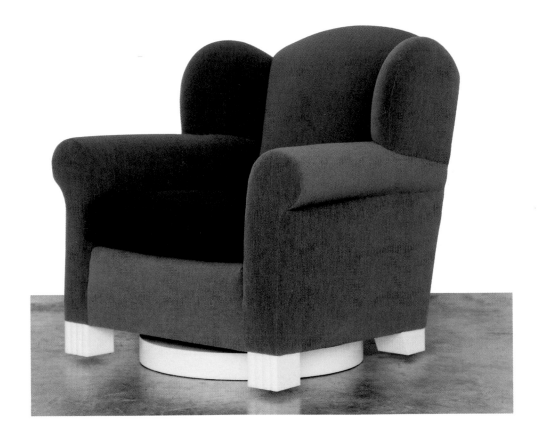

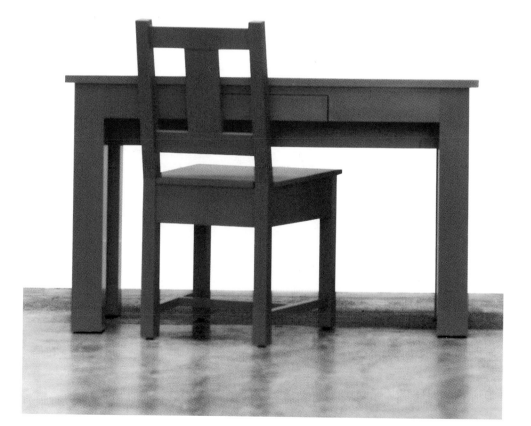

KNEW WRITING
TABLE & CHAIR | 181
Roy McMakin
enameled wood

Locality is very important in my work. Where one lives very much influences one's work. I grew up in the West and can't help but be defined by my environment. When I left Los Angeles, I chose Seattle initially because it is on the West Coast, but the difference of climates and the sense of place between Southern California and the Pacific Northwest has changed my work in a profound way. There is a greater sense of craft here in Seattle than in Southern California, and I would attribute that in some way to the climate and the landscape. It didn't make sense to make fine furniture in Southern California, and I couldn't find the people to make it. Here in the Northwest, there is a history of lumber production being the centerpiece of the people's livelihood, and although the economy has diversified, there are still people in the woods of Washington making their living by gathering lumber and milling the wood. There is a clear and direct connection between the raw materials and the finished product, and that has been important and of great interest to my work. I have found that the people who build my designs and operate my shop here seem to have a certain focus, a different standard than what I was used to.

roy mcmakin

Making furniture well is an important idea for me, and part of my growth as a furniture designer was the frustration of how to get things made and what it means to make things. Making furniture for the Getty Museum led to my desire for a certain understanding of craft and a level of perfection. Part of that understanding is a respect for the material, for the wood. It's important that there is enough time to build something really well, and to derive pleasure from this. Quality and craftsmanship is an interesting part of the conceptual quality of the work. I try to invest the furniture with a sense of humor or wit, but also with a certain complexity that is very much a part of our lives. I am not sure there are any specific sources or influences where this came from, but it has been central from the very beginning.

What I try to achieve in the furniture pieces is a particular characteristic that is hard to pin down, whether it is somber or it is playful, whether it is old or it is new. The early twentieth-century California architect Irving Gill has been a huge influence on me. I first encountered his work when I was going to school in San Diego, and I became almost obsessed with it. I moved to Los Angeles because a lot of his work is there. What I have learned from Gill is the importance of initially setting up some sort of formalist system or structure. Invariably you will at some point have to choose between being rigid and maintaining that system, or breaking that system by letting in something else that may have seemed to come out of left field. It could be as simple as putting a row of windows on a facade and placing something slightly off so it works better. I think there is humor, a certain charm to that: real life intruding or pushing up against the formal, conceptual idea.

I try to invest the furniture with a sense of humor or wit, but also with a certain complexity that is very much a part of our lives.

It is this quality that I try to invest in the furniture I make. I think the minimalist artist Robert Mangold, whose work I have liked since I was quite young, also has this quality. The other thing that influences me enormously is years of junk shopping and a delight and fascination with the vernacular. There is a certain "high design" that I respond to, as well as certain sensibilities in both premodern and modern design from the history books, but what really influences me is a lifetime of going "junking" at thrift stores and antique shops. I am most influenced by the junk that mankind produces and the moment it comes together with an incredible sort of charm. Like Edvard Greig taking a folk song and making it high art, I am more interested in the "found" or homemade pieces and taking inspiration from them.

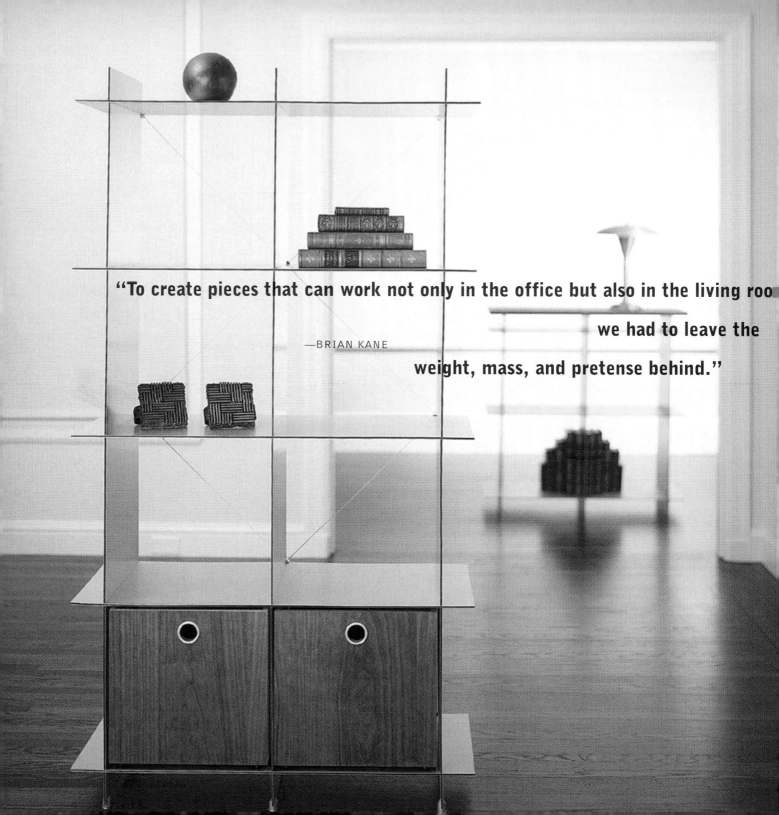

"To create pieces that can work not only in the office but also in the living roo we had to leave the weight, mass, and pretense behind."

—BRIAN KANE

Facing page
**CERISE GRID
& BOX**
*Brian Kane &
Mark Kapka*
aluminum composite, steel cable, cherry plywood

**MUSILEK SIDE
TABLE**
*Aidlin/Darling
Design*
veneered plywood, stainless steel

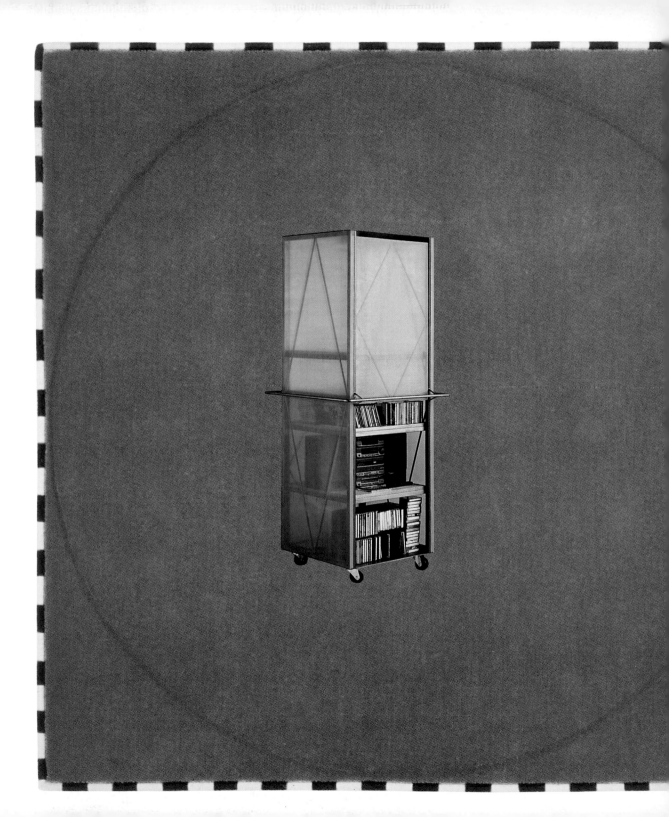

**CIRCLE IN A
SQUARE RUG**
Vicki Simon
wool

A/V CABINET
Alan Sklansky
welded steel,
steel mesh, fir
plywood

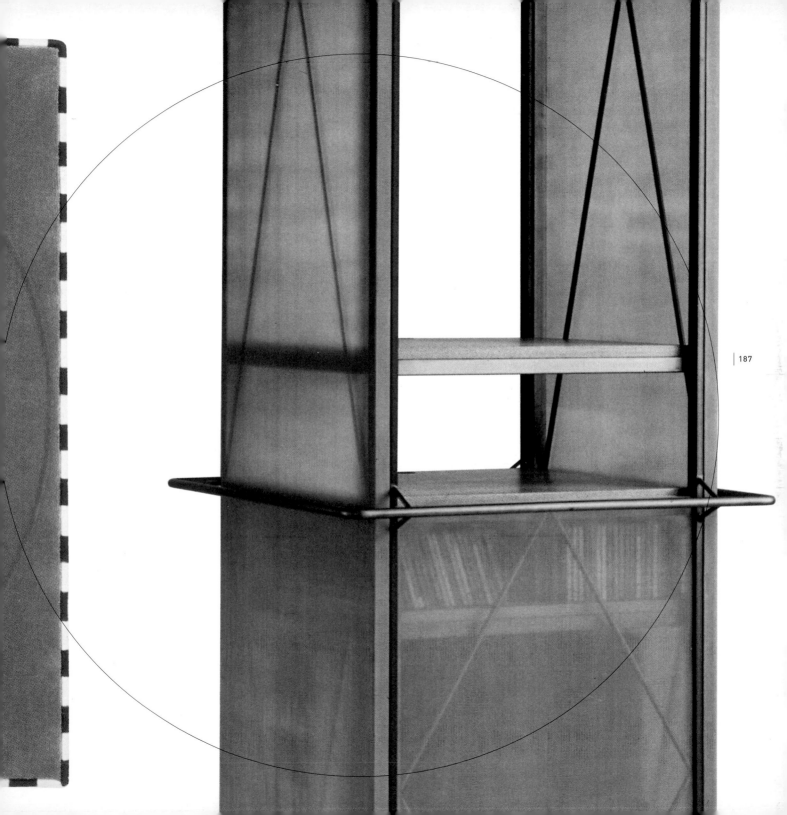

Without clutter
to detract us, we can look to the horizon
and contemplate
life's
less earthly issues.

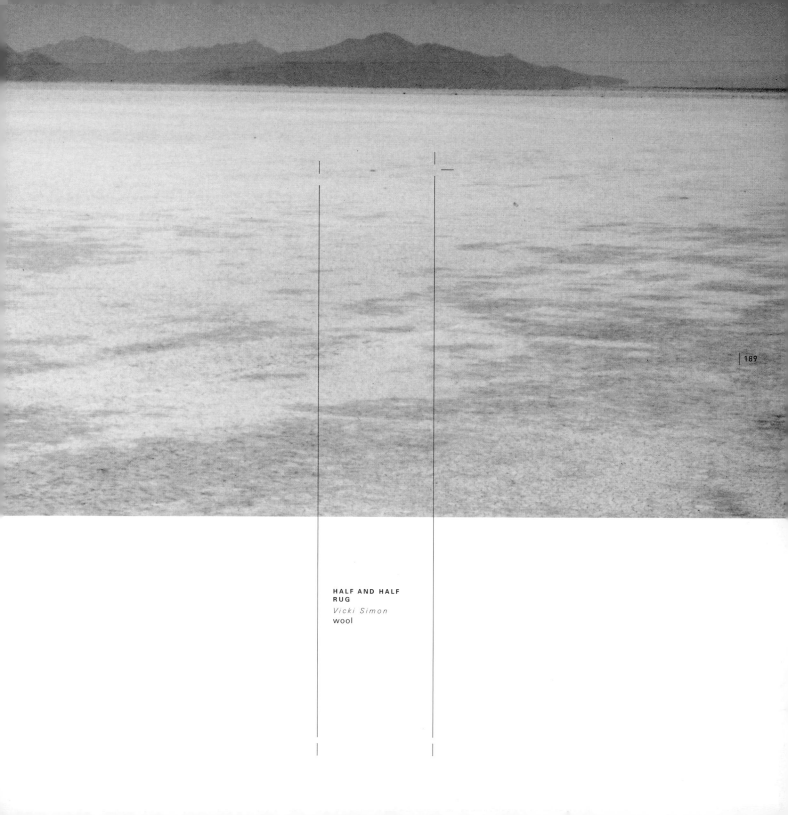

**HALF AND HALF
RUG**
Vicki Simon
wool

190

**MASSIVE
STORAGE UNIT**

Andy Hope
plywood, frosted
glass, magnify-
ing glasses

facing page
**7489 BED & 116
SIDE TABLE**

Daven Jay
veneered ply-
wood, glass

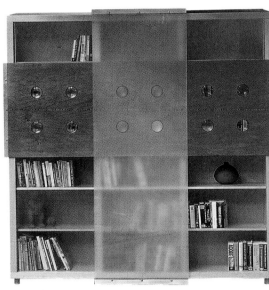

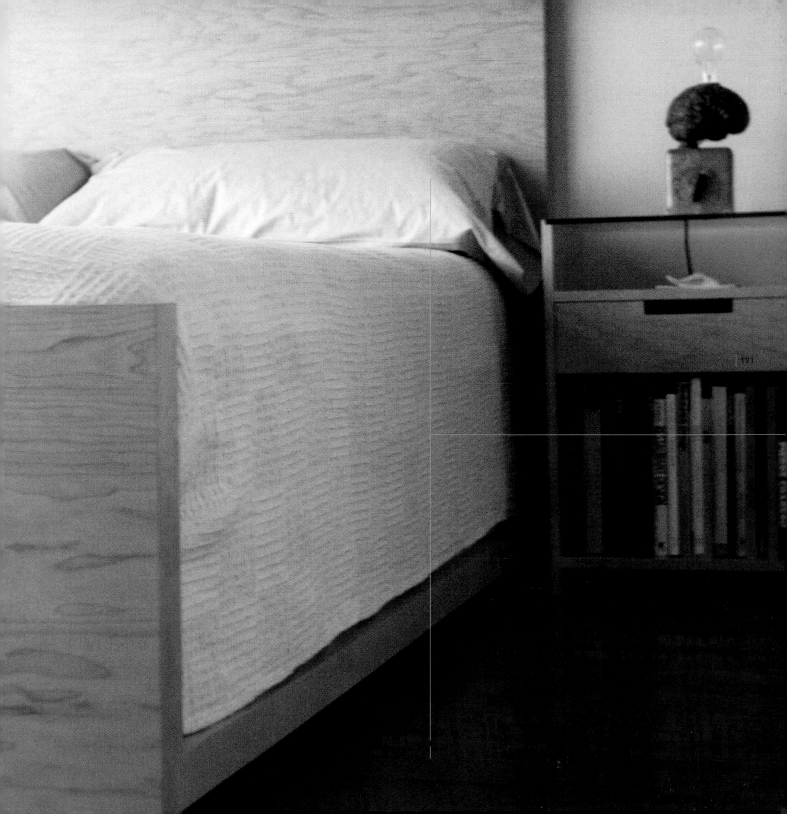

**BENT PLY
STAND**

Eric Pfeiffer
molded
plywood

SHELFCAB

Tim Rempel
plywood, stain-
less steel

**BRICK
CREDENZA**

Ali A. Alam
dyed ash, cast
aluminum

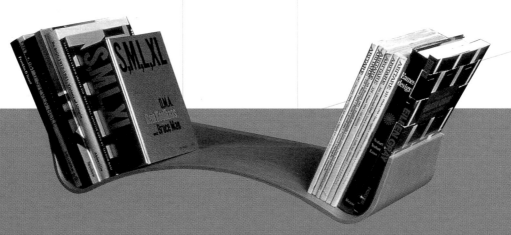

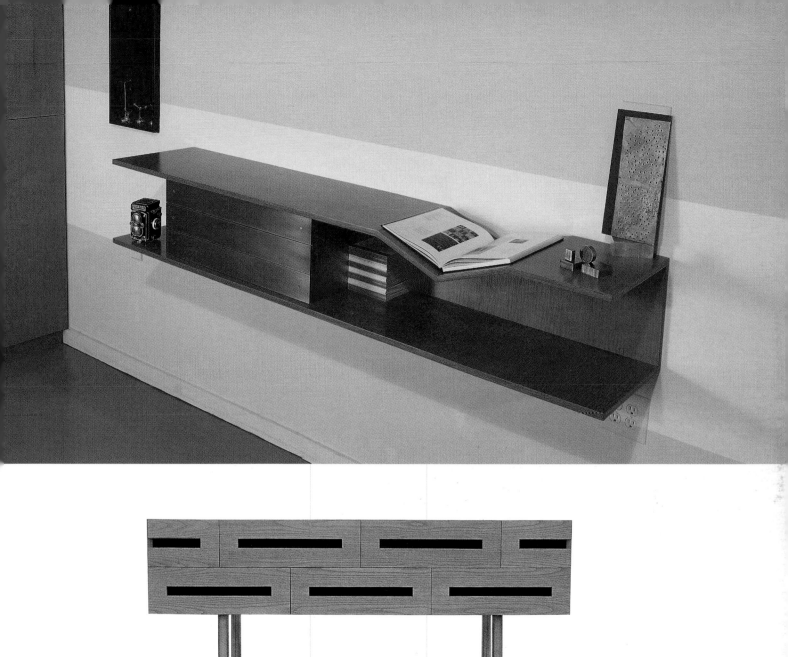

CIRCLE 3 SIDE TABLE

Mark Zuckerman & Monty Lawton painted bent plywood

WIRED BOXES TALL OCCASIONAL TABLE

Eric Pfeiffer maple plywood, stainless steel

LOUNGE NO.4 & END TABLE NO.1

Thomas Jameson harvested mahogany, ultrasuede, nickel-chromed steel

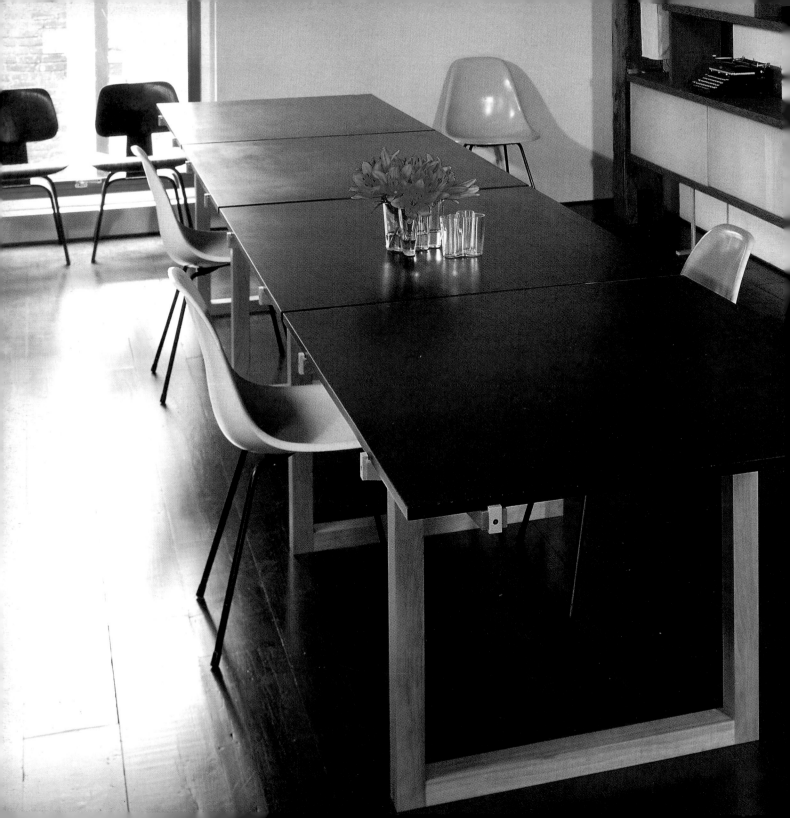

REMSOR FABRIC
Lotta Jansson
woven cotton

**LOW LOUNGER
BEAN BAG**
Eazy Bean
brushed cotton

**ASKO FABRIC
TABLE RUNNER**
Lotta Jansson
linen

Previous page:
**YAMASHITA/
HOLCOMB LOFT
INTERIOR**
*Union
Furniture &
Fabrication*

Simplicity is the ethos of California living.

199

Index of Designers and Furniture

ANGELA ADAMS
273 Congress St.
Portland, ME 04101
207.774.3523 tel
207.874.9819 fax

Argyle Rug
(p. 29)
New Zealand wool
multiple sizes
photo: Jay York

Lulu Rug
(p. 35)
New Zealand wool
multiple sizes
photo: Luc Demers

Manfred Rug
(p. 54)
New Zealand wool
multiple sizes
photo: Luc Demers

JONATHAN ADLER
465 Broome St.
New York, NY 10013
212.941.8950 tel
212.941.8973 fax

Stripe Collection
(p. 44)
ceramic
15" height of tallest
*photo:
Stephanie Day Iverson*

AIDLIN/DARLING DESIGN
245 South Van Ness Ave.
Suite 202
San Francisco, CA 94103
415.621.5603 tel
415.621.0849 fax

Musilek Side Table
(p. 185)
veneered plywood,
stainless steel
36" height
photo: Marcus Hanshin

ALI A. ALAM
Iñex
1431-B Colorado Avenue
Santa Monica, CA 90404
310.393.4948 tel
310.393.3669 fax

Brick Sideboard
(p. 193)
dyed ash, cast aluminum
42" height
photo: Joshua White

HARRY ALLEN & ASSOCIATES
207 Avenue A
New York, NY 10009
212.529.7239 tel
212.529.7982 fax

Rubber Lamp
(p. 68)
pigmented RTV silicone
rubber
11" length

Mitt Lamp
(p. 69)
silicone foam
11" length

Living Systems Grid Table
(p. 77)
stainless steel, wood,
metal laminate
60" length

Chuck Too Chair
(p. 79)
upholstery, chromed steel
73" length
all photos: Liz Deschene

ERIK KAAE ANDERSEN
2021 West Fulton St.
Suite K212
Chicago, IL 60612

Tristan & Iseult Candlesticks
(p. 123)
cast aluminum
18" height of tallest
photo: Gerald Perrone

CHRIS BAISA
Delinear
536 14th St., Suite 4
San Francisco, CA 94103
415.255.8920 tel

Gridloc Table
(p. 170)
1/4" CMC-cut plywood
18" height
photo: Dwight Eschliman

STUART BASSECHES
biproduct
97 Fifth Ave., #4A
New York, NY 10003
212.255.3033 tel
212.243.2894 fax

Stacking Lamps
(p. 74)
powder-coated aluminum,
anodized aluminum, steel
mesh
variable heights
photo: Alec Hemer

BENZA, INC.
413 West 14th St.
Suite 301
New York, NY 10014
212.243.4047 tel
212.243.4689 fax
www.benzadesign.com

Urchin Containers
(p. 80)
design: Roberto Zanon &
Satomi Yoshida-Katz
cast resin
8.5" height

Boing Dish
(p. 80)
design: Giovanni Pellone
acrylic, stainless steel
12" width
*all photos: Giovanni
Pellone*

JEFFREY BERNETT
Studio B
270 Lafayette St.
Suite 402
New York, NY 10012
212.334.9109 tel
212.334.8315 fax

Monza Chairs
(p. 50)
Jeffrey Bernett for
Cappellini
high-gloss powder-coated
steel
23.5"/27.5" heights
*photo courtesy
Cappellini*

CHARLOTTE BJORLIN
Casanova/Bjorlin
171 Pier Ave., Suite 125
Santa Monica, CA 90405
310.664.7097 tel
310.664.7098 fax

Tactic Desk & Tables
(p. 149)
ash, birch, cherry, walnut,
leather
30" height of desk
photo: John Linden

BLASEN LANDSCAPE ARCHITECTURE
2344 Marinship Way
Sausalito, CA 94965
415.332.5329 tel
415.332.4729 fax

Wing Vase
polished recycled cast
aluminum
8" or 16.5" height
photo: J.D. Peterson

BLU DOT
3306 Fifth St. NE
Minneapolis, MN 55418
612.782.1844 tel
612.782.1845 fax
www.bludot.com

all designs: Maurice
Blanks, John Christakos,
Charles Lazor

Stackable Go Cart
(p. 106)
birch plywood, perforated
hardboard
29.5" width

Stackable Files
(p. 108)
birch plywood, steel
22" width

Low Boy
(p. 109)
veneered plywood, steel
36" height

Chicago 8 Box Shelves
(p. 109)
veneered plywood, steel
77.5" height

Modulicious Casegoods
(p. 112)
veneered plywood, painted
steel
47.5" height of tallest
*all photos: Parker
Photographics*

JOSEPH BORON
Joey Manic Inc.
1775A Olive St.
Capitol Heights, MD 20743
877.566.2642 tel
888.898.8002 fax

Virtual Diner
(p. 42)
chromed steel, glass
30" height
photo: Cole Rodger

CONSTANTIN & LAURENE LEON BOYM
Boym Partners, Inc.
17 Little West 12th St.,
#301A
New York, NY 10014
212.807.8210 tel
212.807.8211 fax

Strap Chair
(p. 38)
design: Constantin Boym
& Laurene Leon Boym
wood frame, packing
straps
30" height
photo: Gordon Joseph

"Husband" Armchair
(p. 39)
design: Constantin Boym
ready-made cushion, wood
36" height
photo: Boym Partners

HANNAH BRAND
373 Manhattan Ave.
Brooklyn, NY 11211
718.383.4269 tel

Ting Servers
(p. 75)
low-fire ceramic
14" largest width
photo: Peter Meretsky

MARISSA BROWN & MICHAEL H. GRAVES
Design Toc
50 White St.
New York, NY 10013
212.965.0284 tel
212.334.8197 fax

Perch Barstools
(p. 31)
molded plywood, powder-
coated steel
42.5"/38.5" heights
photo: Paul Whicheloe

TOM BONAURO
George
55 Dorman Ave.
San Francisco, CA 94124
415.642.0684 tel
415.642.1534 fax

**Laurel, Stick & Crown
Chew Toys**
(p. 176)
molded vinyl

8″ length of largest
Crown Bowl
(p. 176)
glazed ceramic
11″ diameter
all photos: Christine Alicino

RUSSELL NORTON BUCHANAN
2801 Lemmon Ave., #201
Dallas, TX 75204
214.979.0207 tel

Grasshopper Screen
(p. 99)
dacron, oak, maple
78″ height
photo: Tom Jenkins

STEPHEN BURKS
Readymade
7 Doyers St., 5th Floor
New York, NY 10013
212.732.0888 tel
212.732.1211 fax

Screen
(p. 51)
enameled steel
63″ height

JEFF COVEY
3483 21st St.
San Francisco, CA 94110
415.282.0593 tel
415.282.0583 fax

Covey Stool
(p. 168)
Jeff Covey for Herman
Miller
cast aluminum or formed
plywood seat, chromed
steel
28″ maximum height
photo: Matt Farruggio

WALTER CRAVEN
Blank & Cables
615 Indiana St.
San Francisco, CA 94107
415.648.3842 tel
415.648.4228 fax

Ladder Boxes
(p. 146)
veneered wood, powder-
coated steel, anodized
aluminum
66″ height
photo: Jeann Stack

Swingside Table
(p. 148)
stainless steel, lacquered
wood, leather
26″ height
photo: Brian Mahany

Box Chair
(p. 164)
wood, leather, aluminum,
stainless steel
34″ height
photo: Brian Mahany

ROGER CROWLEY FURNITURE
217 East 83rd St.
New York, NY 10028
212.439.6002 tel
212.744.7464 fax

Qubik Club Chair
(p. 61)
wool upholstery, wood,
bronze
27.5″ height
photo: Crowley/Becker

FEDERICO DE VERA
580 Sutter St.
San Francisco, CA 94102
415.989.0988 tel
415.989.0468 fax

Chair
(p. 142)
anodized aluminum, hand-
dyed nylon
32″ height
photo: Stefano Massei

CHRISTOPHER C. DEAM
CCD
1177 Tenth St.
Berkeley, CA 94710
510.527.7907 tel
510.525.3036 fax

City Block Storage System
(p. 144)
aniline-dyed plywood,
maple, aluminum
28″ height

Tier Shelves
(pp. 146–147)
design: Christopher C.
Deam & Tim Power
painted MDF or veneered
wood, aluminum
15″ height of each unit
*all photos: Christopher C.
Deam*

NICK DINE
Nick Dine Design
149 Wooster St.
New York, NY 10012
212.598.9707 tel
212.925.0004 fax

Joan Deere Book Carts
(p. 51)
powder-coated steel
30″ width

Point Rey Sofa
(p. 58)
neoprene, steel
84″ length
all photos: Liz Deschenes

JAMES GEIER
555 DFM
1644 North Honore St.
Chicago, IL 60622
312.733.6777 tel
312.733.3083 fax

Forpointe Bench
(p. 105)
oak, aluminum
48″ length
photo: James Geier

EAZY BEAN
42 Rausch St.
San Francisco, CA 94103
415.255.8516 tel
415.255.8014 fax

Low Lounger Bean Bag
(p. 199)
design: Françoise Séjourné
brushed cotton
33″ length
photo: Joe Bud

TOM GHILARDUCCI
1304 SE Palm St.
Portland, OR 97214
503.239.7637 tel
503.232.4957 fax

Soft Box Cushion
(p. 148)
leather
15″ height

4-6-8 Table
(p. 157)
walnut, aluminum
30″ height
all photos: Bob Waldman

MICHAEL GOLDIN
Swerve
2332 Fifth St.
Berkeley, CA 94710
510.549.2332 tel
510.644.0724 fax

GLENDON GOOD
Abraxas
2945 Red Rock Loop Rd.
Sedona, AZ 86336
520.282.6550 tel
520.282.6588 fax

Argus Chaise Lounge
(p. 100)
brushed aluminum,
leather
30″ height

Poseidon Screen
(p. 102–103)
brushed aluminum
76″ height

Atraxia Bed
(p. 104)
brushed aluminum, birch
plywood
36″ height
all photos: Abraxas

JEFF GROSS
one Thing
312 West 20th St.
New York, NY 10011
212.647.0687 tel
212.367.7215 fax

Wink 38 Tiles
(p. 37)
molded polyurethane
*photo courtesy Jeff
Gross*

DAVID GULASSA
6 Dravus St.
Seattle, WA 98109
206.283.1810 tel
206.283.2655 fax

Metal Stool & Wood Stool
(p. 150)
hand-formed metal,
carved wood
15″ height / 16.5″ height
*photos: Marco
Prozzo/Anna Williams*

Vases
(p. 152)
cast rubber
16″ height
*photo: Russell Johnson
& Jeff Curtis*

DAVID GUTHRIE
1121 Willard St.
Houston, TX 77006
713.223.0066 tel
713.223.0068 fax

Rolling Cabinets
(p. 107)
galvanized steel, plywood
90″ height

Dining/Conference Table
(p. 116)
aluminum, glass
30″ height

Chair-4
(pp. 121–122)
baby oak chair, aluminum,
perforated steel
36″ height
all photos: David Guthrie

LAURA HANDLER
161 West 16th St., #18D
New York, NY 10011
212.691.5538 tel
212.727.0441 fax

Gallery Glasses
Laura Handler for
Metrokane
sonically sealed, casted,
colored acrylic
7.75″ height
photo: Kenneth Willardt

ROZ HAYES & DANI STOLLER
Lush Life
672 South Ave. 21, #7
Los Angeles, CA 90031
323.343.9968 tel
213.343.0925 fax

RD 2 Eleven Shelves
(p. 178)
resin-coated plywood,
powder-coated steel
77.5″ height
*photo: Christopher
Nelson*

After-Hours Lounge
(p. 179)
polyurethane upholstery,
powder-coated steel
68″ height
photo: Stephen Oxenbury

Wet Lamp
(p. 179)
powder-coated steel, ball
chain
77.25″ height
photo: Stephen Oxenbury

Mr. Tanaka Chair
(p. 179)
iridescent vinyl, brushed
aluminum
36″ height
photo: Stephen Oxenbury

ANDY HOPE
Co-motion
2900 21st St.
San Francisco, CA 94110
415.282.8975 tel/fax

Massive Storage Unit
(p. 190)
plywood, frosted glass,
magnifying glasses
96″ height
photo: Lance Shows

THOMAS JAMESON
Item Studio
2846 Seventh St.
Berkeley, CA 94710
510.486.8788 tel
510.486 0102 fax
www.itemstudio.com

Lounge no. 4 & End Table no.1
(p. 195)
mahogany, ultrasuede, chromed steel
30" height of chair
photo: David Holbrook

ERIC JANSSEN DESIGN
526 West 26th St., #7F
New York, NY 10001
212.929.8540 tel/fax

Cooler Chair
(p. 90)
expanded polystyrene
39" height
photo: Erma Estwick

LOTTA JANSSON
430 Steiner St., #1
San Francisco, CA 94117
415.436.9327 tel/fax

Remsor Fabric
(p. 198)
woven cotton
48" width

Asko Fabric Table Runner
(p. 199)
linen
14" width
all photos: Lotta Janssen

CHAD JACOBS
Bone Simple Design
17 Little West 12th St. #309
New York, NY 10014
212.627.0876 tel
212.627.2875 fax

Tables
(p. 43)
powder-coated steel, ply-wood
23.5" height of tallest
photo: Ben Parker

Flexion Lamps
(p. 59)
polypropylene
28" height of tallest
photo: John Waldie

DAVEN JOY
Park Furniture
P.O. Box 410415
San Francisco, CA 94141
650.359.9638 tel
650.359.2985 fax

430 Dresser
(pp. 138–139)
stainless steel, aluminum, mahogany, neoprene
30" height
photo: Daven Joy

1514 Bookcase (customized)
(p. 145)
stainless steel, birch ply-wood, aluminum, neoprene
78" height
photos: J.D. Peterson & Daven Joy

7489 Bed & 116 Side Table
(p. 191)
veneered plywood, glass
89" length / 26.5" height
photo: Daven Joy

BRIAN KANE & MARK KAPKA
Brian Kane Design
570 Alabama St.
San Francisco, CA 94110
415.864.0980 tel
415.864.0283 fax

Cerise Grid & Box
(p. 184)
aluminum composite, steel cable, cherry plywood
65" height
photo: Steve Burns

DAVID KAWECKI
3D: Interiors
1304 Haight Street
San Francisco, CA 94117
415.863.0373 tel
415.863.0371 fax

Puzzle Chair
(p. 171)
laser-cut 1/4" plywood
32.5" height
photo: David Kawecki

DAVID KHOURI
Comma
9 West 19th St.
New York, NY 10011
212.929.4866 tel
212.924.3667 fax

Screen 2
(p. 33)
lacquered acrylic
68" height

Zelpha Table
(p. 56)
stainless steel
72" width

LoveMe Cocktail Table
(p. 57)
lacquered wood, stainless steel
42" width

Mary Jane Console
(p. 62)
cast resin, aluminum, honed marble
21" height

Valet of the Dolls Table
(p. 63)
cast polyester resin, acrylic
29" height

TV-Time Throw Cushions
(p. 76)
urethane, walnut
23" width
all photos: Gino Gareza

KNOTHEAD FURNITURE
314 West Institute Pl.
Chicago, IL 60610
312.988.9100 tel
312.988.7146 fax

Hanging Luminaire
(p. 124)
design: Peter Landon & Jeff Bone
birch, frosted glass
10.25" height
photo: Jeff Bone

CHRIS LEHRECKE
Pucci International
44 West 18th St.
New York, NY 10011
212.633.0452 tel
212.633.1058 fax

Wood Pedestals
(p. 64)
turned solid wood
28" height of tallest
photo: Antoine Boots

MIRANDA LEONARD
PII, Inc.
524 San Anselmo Ave., #126
San Anselmo, CA 94938
415.488.1905 tel
415.488.1647 fax

Nesting Tables
(p. 154)
Kevlar, graphite-Kevlar hybrid, fiberglass
30" height
photo: PII

MAYA LIN
Knoll
105 Wooster St.
New York, NY 10012
212.343.4000 tel
212.343.4180 fax

The Earth Is (Not) Flat Stones
(p. 60)
fiberglass-reinforced cement
24" height of tallest
photo courtesy Knoll

BRENT MARKEE
Resolute
1013 Stewart St.
Seattle, WA 98101
206.343.9323 tel
206.343.9322 fax

Button Pendant
(p. 155)
etched stainless steel, polycarbonate, brushed stainless steel
19" diameter

Fleurette, Button Down, Tutti Pendants
(p. 155)
etched stainless steel, polycarbonate, brushed stainless steel, anodized aluminum
5"/8.5"/24" heights
all photos: Dan Langley

TODD MATHEWS
Momus
P.O. Box 1183
Ann Arbor, MI 48106
734.998.0098 tel
734.996.8899 fax

Metro Media Cabinet
(p. 113)
mahogany, maple, cherry, chromed steel
54" height

Arc Mirror
(p. 115)
veneered bent plywood
70.5" height
all photos: Bob Foran

EMILY MCLENNAN
701 North Third St.
Minneapolis, MN 55401
612.339.7746 tel/fax

Ladylite Desk Lamps
(p. 127)
various turned solid wood, paper
38" height of tallest

Ladylite Floor Lamps
(p. 128)
various turned solid wood, paper
65" height of tallest
all photos: Emily McLennan

ROY MCMAKIN
Domestic Furniture
1422 34th Ave.
Seattle, WA 98122
206.323.0198 tel
206.323.6993 fax

Knew Swivel Wingback Chair
(p. 180)
mohair upholstery, wood
37" height

Knew Writing Table & Chair
(p. 181)
enameled maple
33" height of table
all photos: Mark Woods

ROSS MENUEZ
186 Powers St.
Brooklyn, NY 11211
718.218.8147 fax
menuez@hotmail.com

DOCZi Lamp
(p. 45)
nylon
12" height

Domino Sofa
(pp. 46–47)
Ross Menuez for IDEE
stainless steel, foam
68" length

Vanilla Fudge Lounge
(p. 59)
stainless steel, nylon
82" length

Bakelite Screen
(p. 65)
phrenolic tubing, aluminum
80" height
all photos: Liz Deschenes

MARRE MOEREL
182 Hester St., #13
New York, NY 10013
212.219.8985 tel
212.925.2371 fax

Blotter Rocking Chaise Lounge
(p. 35)
stainless steel, rubber
64" width

Soft Box Lights
(p. 53)
earthenware ceramic
23" height of tallest
all photos courtesy
Marre Moerel

MORRIS / SATO STUDIO
219 East 12th St., 1st Fl.
New York, NY 10003
212.228.2832 tel
212.505.6160 fax

Pearce / Quinn Loft Interior
(pp. 48–49)
design: Michael Morris &
Yoshiko Sato

photo: Michael Moran

STEPHAN NESVACIL
1820 West Hubbard St.
Chicago, IL 60622
312.997.2170 tel
312.997.2208 fax

Geometric Low Table
(p. 114)
maple, lacquered wood
15" height

photo: Marty Levin

THOMAS OLIPHANT
1500 Jackson St. NE
Minneapolis, MN 55413
612.781.8851 tel

Dining Chairs
(p. 124)
stainless steel, molded
plywood, polyester/nylon
fabric
40" height

photos: Kathy Fogerty &
Michael Hang

Rocking Chair
(p. 125)
stainless steel, carbon
fiber/polycarbonate, teak
33" height

photo: Thomas Oliphant

DANTE PAUWELS
Dial Industries
3616 Noakes St.
Los Angeles, CA 90023
800.624.8682 tel

Pop-Up Fruitatious Bowl
(p. 172)
colored polypropylene,
nickel-plated snaps
11.5" diameter

Pop-Up Petal Vase
(p. 172)
colored polypropylene,
nickel-plated snaps
6.5" height

**Pop-Up Nightlight
Table/Lamp**
(p. 173)
colored polypropylene,
nickel-plated snaps
30" height

all photos:
Dante Pauwels

PABLO PARDO
1526 Wallace Ave., Studio C
San Francisco, CA 94124
415.822.2712 tel
www.pablodesigns.com

Sail Light
(p. 167)
mylar, machined aluminum
13" height

photo: Marcus Hanschen

Uno Paper Bin
(p. 174)
die-cut birch plywood
15" height

photo: Leigh Beisch

ERIC PFEIFFER
Bravo 20
161 Natoma St.
San Francisco, CA 94105
415.495.3914 tel
415.495.4678 fax

Coat Hanger
(p. 143)
cast aluminum, stainless
steel
72" height

Low Bone Table
(p. 177)
plywood, plastic laminate,
powder-coated steel

Bent Ply Stand
(p. 192)
molded plywood
28" length

**Wired Boxes Tall
Occasional Table**
(p. 194)
maple plywood, stainless
steel
43" height

all photos: Jeann Stack

ALEXANDER PORBE
Incite Design
6447 Mack Ave.
Detroit, MI 48207
313.921.7333 tel
313.921.7377 fax

Orbit 0697 Light
(p. 122)
blown glass, stainless
steel, rubber
18" height

photo: Steve Lengnick

JOHN RANDOLPH
Randolph Design
70 Glen Dr.
Sausalito, CA 94965
415.332.7374 tel
www.randolphdesign.com

Scissor Table
(pp. 160–161)
maple plywood,
solid maple, steel
32" tallest height

photo: Peter Belanger

KARIM RASHID
Karim Rashid Industrial
Design
357 West 17th St.
New York, NY 10001
212.929.8657 tel
212.929.0247 fax

Space Chaise
(p. 29)
Karim Rashid for IDEE
chromed tubular steel,
neoprene, colored plexi-
glass
76" length

photo courtesy Karim
Rashid

**Spline Armchair &
Electrolyte Lamp / Shelf**
(p. 36)
Karim Rashid for IDEE
chromed steel, wool
upholstery; powder-coated
steel, translucent plexi-
glass
28" height of chair

photo courtesy Karim
Rashid & IDEE

TVC 15 Cabinets
(p. 40)
Karim Rashid for IDEE
high-gloss powder-coated
steel
26" height

photo courtesy Karim
Rashid & IDEE

Salt & Pepper Collection
(p. 41)
Karim Rashid for Nambe
Studio
polished metal alloy
8" height of tallest

photo: David Bashaw

ASYM Chairs
(p. 53)
Karim Rashid for IDEE
lacquered plywood,
chromed steel
32" height

photo courtesy Karim
Rashid & IDEE

Kid Chair
(p. 55)
Karim Rashid for Fasem
leather, chromed steel,
hemp
32" height of tallest

photo courtesy Karim
Rashid & Fasem

Triaxial Chaise / Couch / Bed
(p. 78)
wool upholstery, chromed
steel
76" maximum lenth

photos: Doug Hall &
Karim Rashid

Garbo Container
(p. 83)
Karim Rashid for Umbra
polypropylene
17" height

photo courtesy Karim
Rashid & Umbra

Aura Coffee Table
(p. 84)
designed for Sandra
Gering / produced by
Zeritalia
painted glass, chromed
steel
18.5"

photos: Doug Hall

Oh Chair
(p. 85)
Karim Rashid for Umbra
injection-molded plastic,
chromed steel
32" height

photo courtesy Karim
Rashid & Umbra

TIM REMPEL
2213 Fifth St.
Berkeley, CA 94710
510.845.9777 tel
510.845.9778 fax

Shelfcab
(p. 193)
plywood, stainless steel
68" length

photo: Perre-Yves
Goavec

BUDDY RHODES
2130 Oakdale Ave.
San Francisco, CA 94124
415.641.8070 tel
415.641.1575 fax
www.buddyrhodes.com

Cone Table
(p. 151)
precast color-infused
concrete
44" height

photo: Christine Alicino

JEFF & LARISSA SAND
South Park Fabricators
136 South Park
San Francisco, CA 94107
415.974.6622 tel
415.777.8633 fax

Universal Chair
(p. 143)
cast aluminum, formed
maple plywood
31.5" height

photo: J.D. Peterson

PETER SANDBACK
940 Arlington St.
Oakland, CA 94608
www.sandbackfab.com

Thick Top Tables
(p. 153)
lightweight colored cast
concrete, wood
12.5" height

photo: Peter Sandback

DENYSE SCHMIDT QUILTS
68 Riverside Dr.
Fairfield, CT 06430
203.254.3264 tel/fax

"Hotter by the Dozen" Quilt
(p. 52)
machine-pieced, hand-
quilted
multiple sizes

LLOYD SCHWAN DESIGN
195 Chrystie St., #809
New York, NY 10002
212.375.0858 tel
212.375.0887 fax

Irkle Shelves
(p.32)
Lloyd Schwan for
Cappelini
lacquered wood
82" height

Skin Floor Lamp
(p. 34)
rayon, stainless steel
68" height

Stackable Help Shelves
(p. 40)
Lloyd Schwan for Box
Design
oil-finished oak
77" height

Skeleton Chair
(p. 42)
chromed steel
36" height

Crinkle Lamps
(pp. 66–67)
Lloyd Schwan &
Lyn Godley for the
MoMA Store
PVC
12"

Dancer Cabinets
(pp. 86–87)
painted, stained wood
72" height
*all photos courtesy
Lloyd Schwan*

SEAN SCOTT
Niedermaier Inc.
2650 West Fulton St.
Chicago, IL 60612
773.722.1000 tel
773.722.5280 fax

S-3 End Table
(p. 119)
lucite, stainless steel
24" height
photo: Susan Kezon

VICKI SIMON
Rugs by Vicki Simon
442 Post St., Suite 302
San Francisco, CA 94102
415.576.0500 tel
415.576.0501 fax

Circle in a Square Rug
(p. 186)
wool
48" width

Half and Half Rug
(p. 188)
wool
72" length
*all photos:
Annabelle Breakey*

ALAN SKLANSKY
1286 63rd St.
Emeryville, CA 94608
510.547.1270 tel/fax

Display Sideboard
(p. 165)
maple plywood, welded
steel, perforated-metal
grating
48" maximum height

A/V Cabinet
(pp. 186–187)
welded steel, steel mesh,
fir plywood
76" height
all photos: Christine Alicino

PAUL SMITH
940 Arlington Ave., #1
Oakland, CA 94608
510.547.2271 tel/fax

End Grain Coffee Table
(p. 36)
aluminum, Douglas fir
12.5" height
photo: Paul Smith

MICHAEL SOLIS
Worx
240 Carlton Ave.
Brooklyn, NY 11205
718.222.4607 tel/fax

Grid Six Cabinet
(p. 45)
glass, powder-coated
steel, wood, rubber
54" height
photo: Worx

DANIEL STRENG DESIGN
120 North Green St., Suite 4D
Chicago, IL 60607
312.421.1299 tel
www.suba.com/~streng/

Satellite Chair
(p. 118)
fiberglass, carbon fiber,
polyester resin
31" height

Yaozer Planter
(p. 118)
terra cotta
5.5" height
*all photos courtesy
Daniel Streng*

STUDIO EG
2431 Peralta St., Suite 2437A
Oakland, CA 94607
510.763.8812 tel
www.studioeg.com

M. ALI TAYAR
Parallel Design
Partnership
430 West 14th St., Suite 408
New York, NY
212.989.4959 tel
212.989.4977 fax

Niloo's Cut-out Table
(p. 34)
M. Ali Tayar for ICF
plastic-laminate surface
MDF, glass
71" length
photo: David Sundberg

Michael's Table
(p. 54)
molded plywood, alu-
minum, glass
15"/30" heights
photo: David Sundberg

Rassamny Chair & Stool
(p. 70)
M. Ali Tayar for ICF
oiled teak, anodized
aluminum
31.5" height of chair
photo: Joshua McHugh

Plaza Screen
(pp. 70–71)
M. Ali Tayar for ICF
extruded aluminum
72" height
photo: Joshua McHugh
extruded aluminum
7" length
photo: Joshua McHugh

CANAN TOLON
1608 63rd St.
Emeryville, CA 94608
510.420.0669 tel
510.420.7059 fax

Swivel
(p. 156)
welded steel, glass
28" height

Seatable
(p. 158)
cold-rolled bent sheet
metal
42" maximum height
all photos: Ben Blackwell

BRUCE TOMB
Infinite Fitting
1240 Valencia St.
San Francisco, CA 94110
415.970.9210 tel
415.970.1492 fax

Wash Stand
(p. 137)
white bronze, maple,
stainless steel, Sierra
granite
40" height
photo: Paul Warchol

RODNEY ALLEN TRICE
T.O.M.T.
464 Fifth St.
Brooklyn, NY 11215
718.237.9781 tel
718.832.2117 fax

Hose Hassock
(p. 91)
ready-made garden hose
parts
11" height

Luggage End Table
(p. 92)
used suitcase, furniture
legs
18" height
photos courtesy T.O.M.T.

**UNION FURNITURE &
FABRICATION**
1046 39th St.
Emeryville, CA 94608
510.652.0602 tel
510.652.0606 fax

Spring Back Chair
(p. 141)
design: Matthew Bear
maple
32" height

Yamashita/Holcomb Loft
(pp. 196–197)
design: Matthew Bear &
Scott Moulton
all photos: John Edwards

**MARK WADSWORTH
DESIGN**
370 North Draper Ln.
Provo, UT 84601
801.492.1264 tel
801.492.0624 fax

Chaise Lounge
(p. 101)
birch, anodized aluminum
72" length
photo: Cristy Powell

Plywood Table
(p. 117)
plywood, anodized alu-
minum
31" height
photo: John Rees

**DAVID WEEKS LIGHTING
STUDIO**
61 Pearl St., #612A
Brooklyn, NY 11201
718.596.7945 tel/fax

Tripod No. 303 & Double
Pod No. 305
(p. 30)
stainless steel, brass,
black anodized aluminum
75" maximum height

**Two-Arm Bottle Sconce No.
203**
(p. 30)
nickel-plated steel, silver
anodized aluminum
27" width

**Wood Point Pendant No.
413 & Wood Curve Pendant
No. 414**
(p. 41)
varnished ash, anodized
aluminum; ebonized
mahogany, painted alu-
minum
16.5" height
all photos: Alex Hayden

SIGMAR WILLNAUER
Shelter and Roam
333 Central Park West
New York, NY 10025

Zip Light
(p. 166)
natural leather or suede
rubber, titanium dioxide-
coated polyester, zippers
22" height

Zip Table
(p. 175)
birch plywood, zippers
20.5" height
all photos: Goods!

**MARK ZUCKERMAN/
MONTY LAWTON**
In House
7370 Beverly Blvd.
Los Angeles, CA 90036
323.931.4420 tel

The Thing Cushions
(p. 178)
upholstery, steel
16" height
photo: James Gabbard

Circle 3 Side Table
(p. 194)
painted bent plywood
22" height
photo: Michael Lorrig

Index of selected retail stores

East

FURNITURE CO.
818 Greenwich St.
New York, NY 10014
212.352.2010 tel
212.352.2083 fax

HOMER
939 Madison Ave.
New York, NY 10021
212.744.7705 tel
212.744.7359 fax

MICHAEL'S DOOR
2701 South Macdill Ave.
Tampa, FL 33629
813.835.9509 tel
813.831.1014 fax

MOSS
146 Greene St.
New York, NY 10012
212.226.2190 tel
212.226.8473 fax

REPERTOIRE
114 Boylston St.
Boston, MA 02116
617.426.3865 tel
www.repertoire.com

TOTEM
71 Franklin St.
New York, NY 10013
888.519.5587 tel
www.totemdesign.com

TROY
138 Greene St.
New York, NY 10012
212.941.4777 tel
212.941.5742 fax

In-Between

MANIFESTO
755 N. Wells St.
Chicago, IL 60610
312.664.0733 tel
312.664.5472 fax

ROOM & BOARD
700 N. Michigan Ave.
Levels 6&7
Chicago, IL 60611
312.266.0656 tel

ROOM & BOARD
222 Detroit St.
Denver, CO 80206
303.322.6462 tel
(call for other locations)
www.roomandboard.com

SUNSET SETTINGS
1729 Sunset Bld.
Houston, Texas 77005
713.522.7661 tel
713.529.6669 fax

West

AERO & CO.
4651 Kingswell Ave.
Los Angeles, CA 90027
323.665.4651 tel
323.668.1685 fax

FILLAMENTO
2185 Fillmore St.
San Francisco, CA 94115
415.931.2224 tel
415.931.6304

LIMN
290 Townsend St.
San Francisco, CA 94107
415.543.5466 tel
415.543.5971 fax
www.limn.com

OK
8303 Third St.
Los Angeles, CA 90048
323.653.3501 tel
323.653.2201 fax

URBAN EASE
1919 Second Ave.
Seattle, WA 98101
206.443.9546 tel
www.urbanease.com

ZINC DETAILS
1905 Fillmore St.
San Francisco, CA 94115
415.776.2100 tel
www.zincdetail.com

Cyberspace

AMERICAN
CONTEMPORARY
FURNITURE:
www.tomorrowsclassics.com

DESIGN WITHIN REACH:
www.dwr.com

FULL UPRIGHT
POSITION:
www.f-u-p.com

HERMAN MILLER for the
HOME:
www.hmhome.com

ICF GROUP
www.icfgroup.com

SUPPORTING PHOTO CREDITS

OPENING VISUAL ESSAY:
All images by Richard Barnes
p. 1 "Bakersfield Drive-In #2," 1979.
p. 2 "San Francisco Museum of Modern Art," 1995.
p. 3 "Space Needle, Seattle," 1993.
p. 4 "Oil Tank, Maine," 1990.
p. 5 "High Desert Ecosphere, Biosphere II," 1997.
p. 6 "Sweetheart Cup Factory," 1995.

INTRODUCTION:
p. 14 "Mies MR10 Chair," 1999. By Ian Reeves
p. 15 "Eames RAR Chair," 1999. By Ian Reeves
 "Eames Storage Unit," 1999. By Ian Reeves
p. 16 "Teodora Chair." Courtesy Vitra, Inc.
 "Greene Street Chair." Courtesy Vitra, Inc.
 "W.W. Stool." Courtesy Vitra, Inc.
p. 17 "Nelson Marshmallow Sofa," 1999. By Ian Reeves
 "Mouille Floor Lamp," 1999. By Ian Reeves
 "Wall Unit for the Maison du Mexique," 1999. By Ian Reeves
p. 18 "Prouvé Antony Chair," 1999. By Ian Reeves
 "Judd Library Chair," 1999. By Ian Reeves
p. 19 "Rodin's Thinker," 1995. By Richard Barnes

CHAPTER I
p. 20 "New York," 1998. By Raul Cabra
 "Untitled (Elevated)," 1999. By James Chiang
p. 21 "Untitled (Cafe)," 1999. By Deborah Siedman
 "Untitled (Subway)," 1999. By Deborah Siedman
 "Untitled (Fruitstand)," 1999. By Deborah Siedman
 "Untitled (Moving)," 1999. By James Chiang
 "Untitled (Display)," 1998. By Raul Cabra
 "Magazine Stand," 1998. By Raul Cabra
p. 28 "Untitled (Ride)," 1998. By James Chiang
p. 35 "Untitled (Back)," 1998. By James Chiang
p. 50 "Missed," 1999. By Raul Cabra
p. 56 "Untitled (Ride)," 1998. By James Chiang
p. 64 "Untitled (Grass)," 1998. By James Chiang
p. 82 "Untitled (Heather)," 1999. By Dino Dinco
p. 93 "Untitled (Past, Present, Future)," 1998. By James Chiang

CHAPTER II
p. 94 "El Trencito en la niebla," 2000. By àtica
 "Untitled (Cornfield)," 1999. By Craig McCormick
p. 95 "La Montañita," 1999. By àtica
 "Tracks," 1999. By Ben Thorne
 "The Katz," 2000. By àtica
p. 104 "Untitled (Electrical Field)," 1999. By Ben Thorne

CHAPTER III
p. 128 "Golden Gate Bridge," 1998. By James Chiang
 "Desert," 1997. Courtesy Jeremy Stout
p. 129 "Amanda," 1998. By James Chiang
 "Desert," 2000. By Dung Ngo
 "Untitled (Q)," 1999. By Dino Dinco
 "El Pato Rojo," 2000. By àtica
 "strip," 2000. By àtica
 "14," 2000. By àtica
p. 136 "Water Tower," 1997. By Jeremy Stout
p. 138 "Bay Bridge," 1996. By Herb Thornby
p. 176 "Walter," 1998. By Dung Ngo
p. 188 "Desert," 1997. Courtesy Jeremy Stout

ACKNOWLEDGMENTS

First and foremost, we would like to express our sincere thanks to all the designers in this book for generously contributing their ideas, contacts, and materials. Needless to say, without them, this effort would not exist. We'd also like to acknowledge that there were many more worthy designers out there that we could not include in this volume for lack of space.

Our thanks to Craig Miller, Curator of Architecture, Design, and Graphics at the Denver Art Museum, for his contribution of the foreword; to Richard Olsen and Charles Miers at Universe for their support and vote of confidence.

Our gratitude to Richard Barnes, whose evocative photographic essay set the stage for this book and added a new dimension to the design.

Thanks also go to James Chiang, Dino Dinco, Jeremy Stout, Deborah Seidman, Herb Thornby, Craig McCormick, and Ben Thorne. Their photography gives the book its grit and polish.

Many thanks to the following for their help: Michael and Gabrielle Boyd; Ian Reeves / San Francisco Museum of Modern Art, and Andrew Goetz and Barbara Haas of Vitra. For putting in long hours at the studio and putting up with our frustrations, our thanks to Betty Ho, Tamara Marcarian, Suzanne Scott, Elizabeth Cutter, Supreeya Pongkasem, Raoul Ollman, Santiago Giraldo, Jeremy Stout, Tom Sieu, Tim Carpenter, Dirk Walter, and of course, Walter.

RICHARD BARNES divides his time between commissioned and personal projects. He was the photographer for five books and has had numerous exhibitions both in this country and abroad. His photography is included in numerous public and private collections including the Metropolitan Museum of Art, the Philadelphia Museum of Art, the San Francisco Museum of Modern Art, the L.A. County Museum of Art, and the New York Public Library collections.

JAMES CHIANG is a commercial photographer based in San Francisco. His work is strongly informed by tenets of architecture and industrial design. He is represented by Linda de Moreta.

DINO DINCO is a fashion and fine-art photographer based in Los Angeles. His work has appeared in *Surface, Ray Gun,* and *Spin* magazines.